SECRET BIDEFORD

Peter Christie

AMBERLEY

First published 2015

Amberley Publishing
The Hill, Stroud, Gloucestershire, GL5 4EP
www.amberley-books.com

Copyright © Peter Christie, 2015

The right of Peter Christie to be identified as the
Author of this work has been asserted in accordance
with the Copyrights, Designs and Patents Act 1988.

ISBN 978 1 4456 4484 4 (print)
ISBN 978 1 4456 4504 9 (ebook)

British Library Cataloguing in Publication Data.
A catalogue record for this book is available from the
British Library.

Typesetting by Amberley Publishing.
Printed in Great Britain.

Contents

Foreword

Any visitor to Bideford will be immediately struck by the amazing beauty of its setting either side of a wide estuary with its two halves linked by a magnificent medieval bridge. Ocean-going vessels still tie up alongside the quay right in the heart of the town – which itself is at the centre of a complex of small, and often very steep, streets and lanes that climb up the hills on both sides. New developments have generally been well accommodated, both in the old core and around the urban edges – and Bideford was lucky to have escaped the worst ravages of the 1960s and 1970s 'slum clearance' drives. Though some fine buildings were lost, today's town would still be recognisable to our forefathers of 100, 200 and even 300 years ago. Today, most will see the town for the first time from the high level Torridge Bridge, where Bideford's wonderful setting is immediately apparent – a panoramic vista that is not achievable in many settlements, and one which causes many to immediately make a detour into town to explore further.

If they do, what do they find? Bideford can trace its history back to the Saxons and over the last thousand years its story has been studded with important events and larger-than-life personalities. Much has been written on Bideford, from the first history of the town by John Watkins in 1792 up to the twelve books dealing with the town that I have published over the last thirty years. One might be tempted to ask if there is anything left to find out. Well, as any local historian will tell you, there is always going to be more to be discovered and this book allows me to present some of the more unusual and least known aspects of Bideford's story.

These range from the virtually unknown Protheroe Smith to the internationally renowned Charles Kingsley and from humble council houses to some of the grandest public buildings in the town. Given the 'quirkiness' of many of these 'secret' aspects of Bideford's history, it has not been easy to weave them into a coherent chronological guide. I have, therefore, grouped the stories together, both spatially and by theme. I have enjoyed exploring the town over many years – and I hope you similarly enjoy some of these odder bits of Bideford's story that I have unearthed over that time.

The Bridge and the Town Hall

The first secret of Bideford is how it got its name. The first form we have is recorded in the Domesday Book of 1086 where it appears as 'Bedeford'. A 1232 document spells it 'Budiford', while another from 1238 has it as 'Bydiford'. The settlement seemingly takes its name from a Saxon personal name 'Byda' with 'ford' added as an obvious reference to the old crossing point of the River Torridge at Ford House. It was the Victorians who seem to have invented the derivation 'By-the-ford' – it sounds feasible but is incorrect.

The bridge is the glory of the town, yet there are things about it you may not know. Look over its walls and you will see the waters of the Torridge pouring through, but how many know that the humble mussel used to be part of the defences of the structure? The minutes of the Bridge Trust, who cared for the bridge, have entries such as this from 1734 when George Dennis and two others were paid 5s 6d 'to fetch Mussells for the Bridge'. These were to be placed around the bottom of the bridge pillars to protect the bases from the scouring action of the river. Until the early decades of the twentieth century, a notice used to be prominently displayed warning people not to remove the mussels under pain of court action - and there are records of hungry shellfish gatherers being prosecuted.

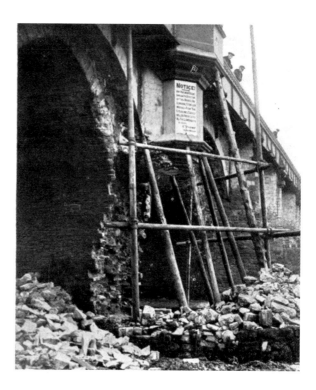

An old picture of the bridge with a notice forbidding the removal of mussels.

Drama is an ephemeral art and records are rare but Bideford can possibly claim a visit from a very famous actor and playwright. At the start of the seventeenth century, there was a scandal involving the misappropriation of funds by the Bideford Bridge trustees which ended up in the Court of Chancery in London in 1608. The money in dispute was earmarked for the repair of the bridge, but had been spent by the trustees on the 'entertaining of strangers and in banqueting and often feasting between themselves, and also for the seeing of stage plays acted within the Town of Bydeford' – at a time when the bridge was 'in divers places Faulty.'

So what stage plays were the trustees treating themselves to? There is a tradition backed up by evidence that William Shakespeare's company of actors visited North Devon in 1605 to escape an outbreak of plague in London, with the company definitely presenting a play in Barnstaple. Given the dates, one has to wonder if they also travelled to Bideford which was then a similar size to Barnstaple – with their fees being paid by the trustees. Where plays were being staged at this time is open to question, but the old marketplace or town hall might have provided suitable venues. If true, then the trustees were more honoured than they probably realised.

A few years ago the county council seriously suggested hanging a stainless steel pedestrian walkway over the side of the bridge to enable the widening of the roadway which, sensibly, was abandoned. This wasn't the first time major alterations to the bridge had been suggested. In 1809, a plan was advanced to install a swing bridge at the eastern end of the bridge to allow large ships to pass through – an idea scotched by the trustees.

In 1898, Capt. Molesworth, a speculator behind much of the development of Westward Ho! as a resort, proposed building a completely new bridge parallel to the existing one which would link the new Bideford–Westward Ho! Railway to the main line at East-the-Water. A public meeting was held where Molesworth said he 'thought that the council would have jumped at the proposal.' Sadly for him, the councillors didn't agree, with Cllr Pollard saying the scheme was 'antagonistic to Bideford both in its commercial value and artistic aspect'. Cllr Tedrake was blunter, saying, 'the scheme would really only benefit the promoters' and Alderman Narraway, the senior councillor, reckoned, 'the Long Bridge was the soul of Bideford' and 'nothing should be allowed to detract from its beauty'. Given these views, it is not surprising to learn that the plans were overwhelmingly voted down by the council – and the bridge is still recognisable as a glorious medieval bridge.

Another story concerning the bridge is very strange indeed. In January 1865, a quarry was opened at Weare Giffard which adjoins Bideford to provide stone for the widening of the bridge. In breaking up the slabs of stone, 'the gads were applied to split them' and to the astonishment of the workmen 'in the middle of the largest stone they found a large rat (supposed to be of the Muscovy breed) of great length from tail to snout, with whiskers 6 inches long.' Back then, toads were relatively often found in the stone, but a live rat was a novel discovery. The animal was captured and was 'to be offered to the British Museum as a curiosity.' Whether this institution took up the offer or not is unknown, but suffice to say nothing more is heard of this bizarre find.

Today's town hall is a fascinating building constructed in 'playful free Tudor' style. Although it looks to be all from one period, there is actually half a century between its two halves. The clue is in the colour of the bricks, with lighter ones making up the older part. Look at the main entrance and to the right the building dates from 1851, to the left the structure was erected in

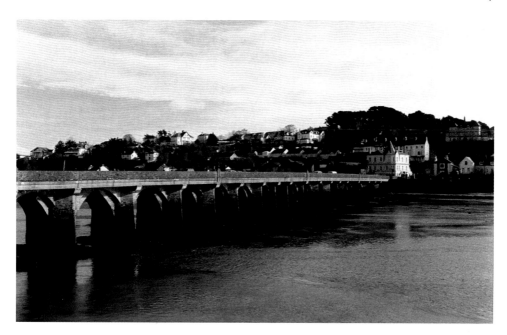

Bideford Bridge. The twenty-four-arched medieval glory of the town.

1904–1906, as shown by an inscription on the corner recording the architect as Alfred Dunn of Birmingham and the builders H. Glover & Son of Bideford. The architect of the first section has also left his mark in the shape of a small plaque at the back of the building showing the initials 'R. G.', plus the symbols of Freemasonry. They record Richard Gould, the borough surveyor of Barnstaple, who designed many public buildings in North Devon.

The original half cost £1,400, while the later section (with the library) came in at £5,492. When first built, the building also housed the police station and the fire engine. The fifty-year gap between the two sections was due to the council not having enough money to continue with the construction – clearly nothing changes. If one looks at the building today, one can see the 1905 date on a drainpipe; clearly someone was expecting the building to have been completed rather earlier than it was!

Within the town hall there are many treasures, including twelve 6-foot-long wooden staves topped with painted oblongs which depict various coats of arms. They appear to date from the latter half of the eighteenth century and were carried by the town's constables. Constables were men elected annually from the citizens to fill the office. They weren't just ceremonial, as it is recorded that wrongdoers had their hands tied to the staves, and were led around the town by constables and publicly whipped as they went, a punishment suffered, for example, by two old men called Hobbs and Hodge in 1828. The staves are in the town council chamber, which is lined with photographs of past mayors, while the larger room next door is used by Torridge District Council – both spaces being unknown to most Bidefordians.

Anyone crossing the bridge must be impressed by the size and solidity of the bridge buildings – yet how many know much about the structure? It was completed in 1882

TO BUILDERS.

THE
TOWN COUNCIL OF BIDEFORD
ARE DESIROUS OF RECEIVING TENDERS FOR
THE ERECTION
OF A NEW
TOWN HALL.

The Plans and Specification may be seen on application at the Office of the Town Clerk, to whom sealed Tenders are to be sent on or before the 19th Instant.

The Contractor will be required to give security to the extent of £500, for the due performance of his Contract.

The Council do not pledge themselves to accept the lowest Tender, and no compensation or allowance will be made to any Person whose Tender may not be accepted.

C. CARTER, Jun.,
TOWN CLERK.

Bideford, 2nd July, 1850.

COLE, PRINTER, STATIONER, ETC., BIDEFORD.

Left: The poster requesting tenders to build the town hall issued in July 1850.

Below: Richard Gould's initials and the Freemasonry symbols on the back wall of the town hall.

Opposite above left: A sketch of the tops of the constable's staves now held in the town hall.

Opposite above right: The town council chamber in the town hall looking towards the mayor's chair.

Opposite below: Torridge's planning committee pictured in the district council chamber – the coat of arms on the wall used to be on the outside wall of the old town hall opposite this site.

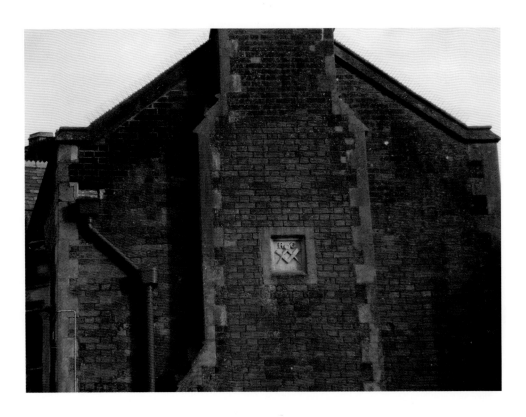

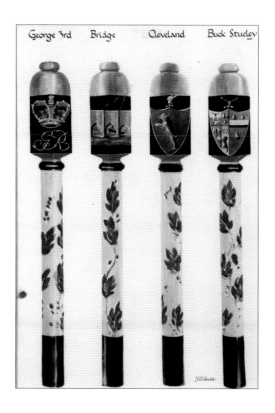

George 3rd Bridge Cleveland Buck Studley

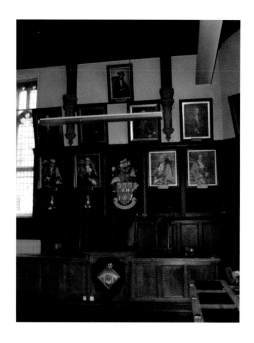

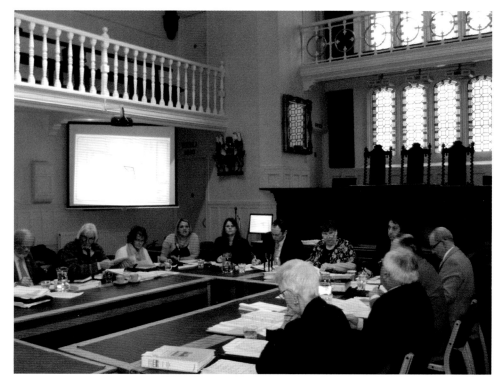

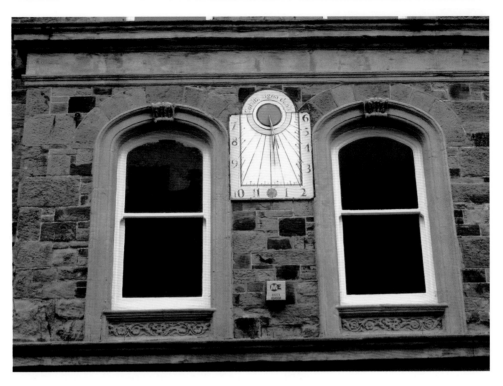

The 1734 sundial, seen today on the south face of Bridge Buildings.

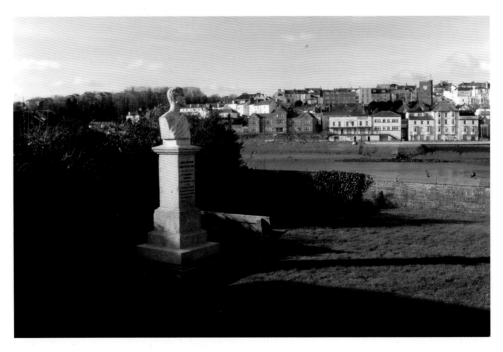

John Pine-Coffin's bust at the eastern end of the bridge.

by the Bridge Trust and replaced an older property dating from 1758 (one replacing an even earlier building) that housed the old town hall, the grammar school and the trustees' meeting hall. The architect was Mr Boyden and the builder R. T. Hookway, while the decorative carvings on the outside were carved by noted sculptor Harry Hems of Exeter. The overall cost was £4,500, which virtually bankrupted the trust.

They were opened by Sir George and Lady Stucley, who lived at Moreton Hall on the outskirts of town, assisted by her brother the Reverend Roger Granville, the rector of Bideford. The new building contained the town's library, a suite of offices, rooms for adult education as well as a caretaker's flat and a 'new Bridge-chamber'.

Eventually, however, the building proved too costly for the Bridge Trust to run and they reputedly sold it to the new Torridge District Council in the 1970s for just £1. Since then, the structure has been extensively refurbished, although the council is now looking to vacate it. What it might become if this happens is anyone's guess, but a modern boutique hotel would be an interesting development given its wonderful central setting overlooking the river and Bridge – with a car park adjacent. We shall see.

The prominent sundial displayed on its Southern face was rescued from the earlier town hall and was first erected by the Bridge Trust in 1734 when George Down was paid £5 5s 'ab[ou]t the Dialls', and John Marshall earned £3 14s 6d for 'painting the fface of the Diall At the Town Hall'. Just to show that human nature doesn't change in the same year, the town crier was paid 6d 'to forewarn people throwing Stones at the Dyall.'

The building was the site of 'a gruesome discovery' in 1912 when the decaying body of John Cridge, the town surveyor, was found locked in an upstairs cupboard a month after he disappeared. The inquest jury found he had committed suicide by swallowing strychnine, but no reason for his actions was found – and as far as I know no one has ever reported a ghost in the building.

At the eastern end of the bridge are two small enclosed areas of grass. Now owned by the Royal Hotel, they were the property of the Bridge Trust who allowed them to be used during the Second World War as the site for water tanks to combat any fires caused by enemy bombs. When emptied prior to demolition, hundreds of coins thrown in 'for luck' provided unexpected treats for local children. Around fifty years beforehand, in 1894, a large group of people gathered to witness the unveiling of the bust of J. Pine-Coffin – but who was he and why did he deserve to be remembered?

The story goes back to the death of Charles Willshire, a prominent member of the North Devon Liberal Party. He died in 1889 and a public subscription quickly raised enough to erect a bust of him in Barnstaple Square, where it still survives. Local Conservatives appear to have been determined to honour one of their own; in 1890, when John Pine-Coffin died aged just forty-eight, a subscription soon raised enough for this 'rival' bust. John himself was a large, local landowner who served as a magistrate, a guardian of the poor (helping to run the workhouse and the system of poor relief) and a county councillor.

The marble carving was undertaken by Mr Wilkinson of Esher, Surrey, and its unveiling was carried out by Lord Clinton, who hoped 'that the youth of Bideford and neighbourhood, when they looked on this memorial would remember that it was a memorial to a good and upright English gentleman who tried to do his duty.' Not a ringing endorsement perhaps – but the bust has now become a part of the landscape of the town.

Churches, Chapels and Charity

The parish church of St Mary's in Bideford looks historic, but for the most part only dates from around 150 years ago. In the 1850s, stiff competition from the town's Nonconformists forced churchgoers to consider updating their church, which dated from the fourteenth century. After some intensive fundraising, work began in 1862 with the demolition of all of the old building bar the tower. The contract was given to E. M. White, a local builder and once the mayor of Bideford, who put in a tender of £3,758 for the work, while the architect was E. Ashworth of Exeter. Rebuilding took three years and the reopening occurred on 12 January 1865 – an event covered in great detail by the *North Devon Journal*.

Built in the perpendicular Gothic style, the interior details were described. The communion rail and altar were both carved from 'old oak belonging to the furniture of the former church'. The whole was lit by seventeen 'elegant brass standards bearing gas burners.' Rather oddly, the new church held 1,200 people – where the old one had held 2,000 – though this was only possible due to the presence of awkward galleries around the walls which were not replaced. A very grand opening ceremony and dinner was held to mark the work's completion and everyone there agreed what a marvellous job they had done.

The only dampener on the day was a letter the *Journal* published from 'The Inhabitants of Bideford', which decried what had happened in the churchyard. Apparently, 'numerous ancient and recent tombs' had been 'rooted up' to accommodate the new building. Burials had been stopped some years before owing to overcrowding, but no map had been drawn up showing where the now desecrated graves were located. The gravestones had apparently disappeared and the letter writers feared they were 'to be macadamized and spread over the yard for pavement'. Intriguingly, the letter also noted that the carved heads on the outside of the church had been produced by the Seymour Bros of Taunton and included 'likenesses of some of the townsmen'. One rather unflattering one was of a 'crusty customer' who had annoyed Seymour Snr. The letter writer was probably seeing the past through rose-tinted glasses, as in 1850 the Mayor said, 'our churchyard, which was a disgrace ... every avenue was quite open and free to the ingress and egress of animals, and as he was passing through it a short time since he saw dogs burrowing into the graves.'

Before the church was rebuilt, the rector followed the old custom of renting out pews to the highest bidder. This led to a hierarchy in church seating with the rich getting the best and the poor being consigned to the least pleasant parts of the building. The two pews either side of the altar belonged to Lewis Buck and S. Ley. Buck was both an MP and 'patron' of the church, while Ley was a major merchant in the town. Adjoining Buck's pew on the south side of the chancel were pews for the lord of the manor and the mayor – clearly the 'great and the good' thought seats nearest the altar were the best. The lady mayoress had her own pew while in the middle of the church there were a whole series of pews bearing the names of local farms such as Oldiscleave, Great Adjavin and Termacott

St Mary's church showing some of the carvings representing Victorian Bidefordians.

(today's Tennacott), which indicated that some seats were linked to specific farms with their tenants getting a reserved pew.

By the south porch and down the southern rear of the building were 'free' seats, while on the north were pews for 'Sunday Scholars'. One seat was intriguingly labelled 'Churching Seat', being reserved for those women who had just given birth and who had returned to church to be symbolically cleansed and blessed. The gallery referred to earlier was reserved for the grammar school boys, the organist (along with his bellows blower sitting in the 'Bellows Seat') and some pews for singers. Rents varied, with John Hockin paying a lump sum of £7 plus 1s per annum rent for a ninety-nine-year lease on 'No. 2 North Aisle'. This renting of pews was seen as a scandal by church reformers and they battled against them for many years. Bideford's disappeared with the rebuilding of the church and seats have been free ever since.

Inside the church is a small wall plaque recording Dr Protheroe Smith who was born in Bideford in 1809 and whose brother, Thomas, served as town clerk for around forty years. Protheroe was apprenticed to his father, who was also a doctor, and then moved to London where he founded the first hospital for women in 1842 to treat 'those maladies which neither rank, wealth, nor character can avert from the female sex.' In 1847, he was the first to use anaesthesia during childbirth after fighting opposition from the church and other doctors. The treatment was only widely accepted when, famously, Queen Victoria had her eighth child using anaesthetic.

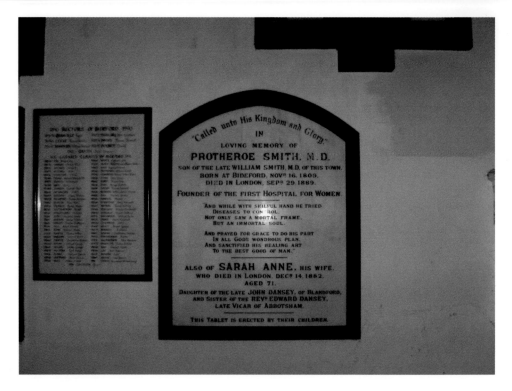

The memorial plaque to Dr Protheroe Smith, who should perhaps be lauded as Bideford's greatest son, in St Mary's church.

Next to the church is the Church Institute, which was built in 1913 as a memorial to the Reverend Roger Granville, rector of St Mary's for many years in the nineteenth century. This contained an extension to the Church Infants' School including, bizarrely, a playground on the flat roof surrounded by a high link fence, which can still be seen today and was in use until 1975.

Churches and chapels today are havens of peace, but in the past they had a rather more torrid history. In 1641, for example, Puritan William Bartlett was appointed lecturer at St Mary's church as part of a Parliamentary policy to undermine Royalist clergy. Soon after, the rector Arthur Giffard was forcibly ejected from his post by cavalry. It was noted that the troops 'used him barbarously making him all over dirt, and some spitting at him as he passed along the street.' The Puritans even removed the glorious Norman font from the church, seeing it 'as a relique of the Whore of Babylon's abominations' and using it as a pig trough; it was later restored to the building. Bartlett himself was expelled when Charles II returned to the throne, though he and his son, John, continued to preach Nonconformist views in secret around the town, being arrested and heavily fined for their trouble.

Giffard's successor was Nicholas Eaton, who had been the first president of Harvard College in New England but was dismissed for 'inhumanity to the students' and is thought to have died in a debtor's prison. He was followed in post by Michael Ogilby, who was charged with drunkenness in 1680, abusing his congregation, using 'unchristian-like

The Church Institute in Lower Meddon Street with the fenced in playground on the roof.

language' to the town clerk and telling a messenger from the bishop of Exeter that 'he could find it in his heart to kill him.'

An interval of peace lasted until the 1740s when John Whitfield became the rector, when 'for nearly forty years the civil and ecclesiastical government of Bideford exhibited a constant state of warfare.' He was a very colourful character and at one point, while in the pulpit, called his own congregation 'Rogues, Scoundrells, Villains, Smugglers, Scum of the Earth, People worse than ye Inhabitants of Sodom and Gomorrah.' No wonder Nonconformist views were so quickly adopted in Bideford.

This growth was helped by the 1689 Toleration Act, which allowed Nonconformists to legally hold services but, as commonly happened, the new group split into two different sects. One, the 'Little Meeting', set up a chapel behind No. 8 High Street, while the other, the 'Great Meeting', established a chapel on the site still occupied by Lavington chapel in Bridgeland Street. Daniel Defoe visited Bideford in the early eighteenth century and noted of the latter place, 'Here is a very large well-built and well furnish'd meeting-house, and by the multitude of people which I saw come out of it, and the appearance of them, I thought all the town had gone hither.' The two groups reunited in 1760. In 1787, the church rector and the Nonconformists jointly funded the first Sunday schools in the town.

Another group of non-conformists were refugee French Protestants or Huguenots who at one time had their own chapel in town but where this was is unknown, whilst one of

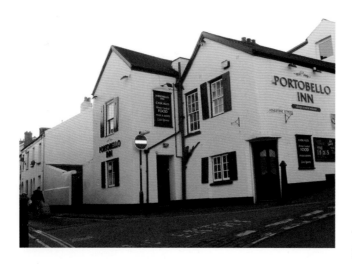

The site where John Wesley preached in 1757.

their number Elisabeth de St.Michel married the famous diarist Samuel Pepys. In 1757 John Wesley rode into Bideford and began preaching outside of the Portobello pub in the Market Place, an event recorded by a plaque on the wall of a nearby house - which seems to have disappeared by the 1920s. No Methodist church was set up until 1788 when a minister was appointed, but he had to deal with constant heckling during services with louts releasing sparrows in the chapel which flew towards the candles and put them out. Notwithstanding this their Bridge Street chapel opened around 1816 with a much larger building constructed in the 1890s which became known as the 'Nonconformist Cathedral of North Devon' so grand was it. In 1913 the Methodists constructed the massive, fortress-like church at the top of High Street – but by the 1960s congregations had shrunk and the Bridge Street building was demolished and turned into a car park (with some burials remaining underneath the tarmac) – which caused major arguments within the group.

Another chapel lost to the town was that of the Bible Christians, a group formed in North Devon. Their chapel was erected in Silver Street in 1844, and when they vacated it became successively a glove factory, a snooker hall and lastly a rather sleazy night-club, which was eventually closed by the police. The building and its later additions were demolished in 2004 and replaced by housing.

The Baptists began around 1808 and were soon publicly baptising adherents in the River Torridge. They then hit hard times, at one point meeting in a coal cellar in Honestone Street. By the 1830s, they had built a church in Gunstone and in the 1960s moved to a new church in Mill Street. Their old building was cleared away and replaced by some sheltered accommodation.

In 1882, the Roman Catholics returned after a gap of around 300 years. Though they faced a wave of stridently anti-Catholic feeling, they did manage to establish themselves and build a small church on a very oddly shaped site at the end of North Road. This was later joined by a convent of French Ursuline nuns in 1906 who began a school which

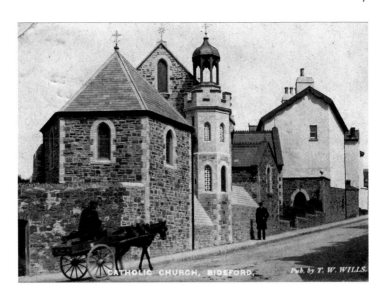

The Bideford Roman
Catholic church soon
after it opened.

lasted until the 1990s. Many other smaller groups have come and gone over the years
and Bideford is still served by groups as widely apart as the Plymouth Brethren and the
Spiritualists.

Bideford, like other towns in Britain, now has a food bank where food is distributed
to those fallen on hard times – yet today's facility isn't the first time such a scheme
has been run in the town. The winter of 1866/67 was noted for its harshness and as
always many of the working class lost their jobs as conditions made it impossible for
them to work outside. In Bideford in January 1867 the Mayor, E. Dingle, called a meeting
'for the purpose of raising a fund to relieve the poor now out of employ in the town
in consequence of the severity of the weather.' Local doctor Thomas Pridham said he
'had seen much of the distress of the poor' – indeed 'few knew more of their necessities
than himself' and he proposed that coal, bread and soup should be distributed rather
than money – a theme echoed by other speakers. The motion to do this was passed
unanimously and the town was divided into 'districts' where collectors could visit asking
for, and distributing, contributions. This was agreed on and an immediate whip-round
from those present raised £50 – at a time when weekly wages were around 10s to 15s for
agricultural workers.

The canvassers met 'with very gratifying results' and around £150 was realised, which
was just as well as they reported that 'a great deal of distress prevails in the town' due
to 'many of the heads of families not having done any work since Christmas.' A soup
kitchen was opened which prepared huge amounts of nutritious soup and 'hundreds of
poor families' received both food and coal – although 'complaint was general that the
soup supplied was badly burnt, and could scarcely be made use of, even by the most
needy.'

By the following week, subscriptions had pushed the total collected up to the wonderful
sum of £200. The Bridge Trustees had also held a joint meeting with the town council
where 'the object of the meeting was to consider the propriety of making a grant out of the

Bridge Fund for the relief of the poor.' After a very brief discussion, the trustees offered £25 to the fund which was gratefully accepted. Over the next few weeks, the money was spent in feeding the needy and providing them with fuel with hopefully no repetition of the burning of the soup!

A drawing of the Bridge Street chapel at the time of its opening in November 1892.

Buried in Bideford

In most towns, some of the most 'secret' areas are the graveyards in that only a few visit them, yet they often have memorials that tell surprising stories. In Bideford there are four extant burial areas: St Mary's churchyard, Old Town, East-the-Water and the borough cemetery.

The first of these is by far the oldest and contains the most bodies, given that it was in use for around 750 years. There are few remaining gravestones, but among them is that of E. M. White, mayor in 1860/61 and noted builder, the marker being just to the right as you enter the churchyard from Bridge Street. His stone records how he built the town hall in 1851, the public rooms in Bridgeland Street in 1869 and rebuilt St Mary's in the 1860s. What it doesn't record is how he made a large sum out of selling the old columns and fittings of the church, which are now found scattered around the area. Also here in an unmarked grave are the remains of 'Raleigh', a Native American Indian who was brought to Bideford by Sir Richard Grenville in 1586 on his return from a colony he had established a year earlier at Roanoke in North America. This man was baptised in St Mary's and given the name of Grenville's cousin, but sadly he only lived a short time and was buried here – the first Native American to be buried in Britain.

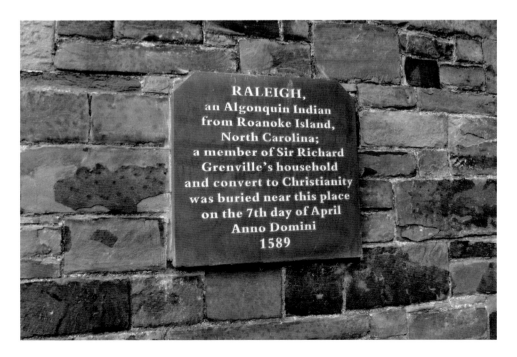

The plaque on St Mary's church recording Raleigh, a Native American.

The second cemetery at Old Town has an odd history beginning in 1742, when the town was hit by a killer disease (probably smallpox) and the Bridge Trust donated a piece of land 60 yards square to the town as an overspill cemetery as St Mary's couldn't cope. In 1841, this was expanded to form a much larger area, becoming the main burial ground for the town until September 1889 when the borough cemetery superseded it. Notable as one of the first council-run cemeteries in England, its birth was anything but smooth as the Church of England demanded that a wall should be built separating their section from that of the Nonconformists – something the latter did not want. If this wasn't bad enough, they also wanted the town's ratepayers to stump up for the cost of the bishop of Exeter consecrating the church section – again a move not designed to please the Nonconformists! A town referendum was called for and this saw the rate suggestion defeated by 262 to 189 votes though the churchgoers didn't take their defeat well. One Capt. Ellis 'avowed his conviction that the auditors must have been guilty of fraud, for he believed it impossible that such could be the result after so much trouble had been taken to bring the voters to the poll.'

The cemetery is still in two sections, with the gravestones in the church section having been placed around the walls while those in the Nonconformist area still stand in their original position. Two of the gravestones in the former section are worth searching, one being, 'To the memory of William Bradshaw Bishop of distinguished Military reputation having fought through the Peninsular and at Waterloo who departed this Life on the 11th

The Nonconformist section of the Old Town graveyard.

September 1862 in his 86th Year'. The other is for William White Peard, who died in 1875 'at Chicago, N.A.' Evidently, his family preferred the old name 'North America' rather than the USA.

One oddity is no longer here. There was once a rare cast-iron grave plaque in memory of Philip Tardrew, an ironmonger, whose shop was in the High Street. Before his death in 1851, he seems to have decided that his business, which was kept running by his family, could benefit from a lasting advertisement as to the benefits of cast iron. The plaque was levered off by vandals some years ago and I rescued it and it can now be seen in the Burton Art Gallery & Museum in town.

The East-the-Water cemetery was opened in 1890 and today is virtually full and will soon be closed to new burials. It is notable for containing three military gravestones. Two mark the resting place of Victoria Cross winners: Lt-Gen. Sir Gerald Graham and Gen. George Channer. Graham was born in 1831 and attended the Royal Military College in Woolwich from where he joined the Royal Engineers and took part in the Crimean War (1853–56). It was during the attack on the Redan redoubt in 1855 that he won his VC. Gen. Graham died in retirement and was buried in Bideford. His fellow general, George Channer, was born in India in 1843, joining the Bengal Infantry in 1859. He later served with the Gurkhas and took part in the Afghan War of 1878–80 but won his VC during an attack on a stockade in Malaya in 1875. He retired to Westward Ho! in 1892, where he died thirteen years later and was buried near to his fellow medal winner.

The other gravestone worth searching out is one of the military ones erected by the Commonwealth War Graves Commission. This is rare as it dates from the First World War era when most casualties were buried on the battlefield whether in France, Gallipoli or elsewhere. Unusually, it records a woman – Mildred Mary Johns, an Army nurse, who died in July 1919 aged just twenty-two while nursing war casualties. There is another peculiarity about this cemetery – the low wall at the bottom of the site is made of hundreds of lengths of marble and granite. These were removed from around graves to make mowing and upkeep easier and were put to use in this unusual way.

The borough cemetery is still in use, being divided by a small country road between older and more modern burials. In the older section is the grave of Albert Inkerman Rogers (1866–1959), who produced several local history books. He got his unusual middle name (which he generally used in preference to Albert) from his father who was present at the November 1854 Battle of Inkerman in the Crimean War, and who came to Bideford as the training sergeant for the local Rifle Volunteers.

Human skeletons have been found in two other places. When the second part of the town hall was being built in 1904 the workmen uncovered eighteen skeletons about 10 feet below ground. These were stained black owing to them being under a layer of culm (a local form of carbon-rich coal). The site was fairly close to St Mary's churchyard, but they were far enough away to suggest no connection. Who these people might have been has never been satisfactorily explained, but their bones were laid to rest in the churchyard, an abiding mystery to this day.

The other skeletons are not quite as mysterious as we think. We know who they were, but where they were found is odd. During the Seven Years War (1754–63), Bideford was the site of two prisoner of war camps for around 1,000 French prisoners: Pillmouth and

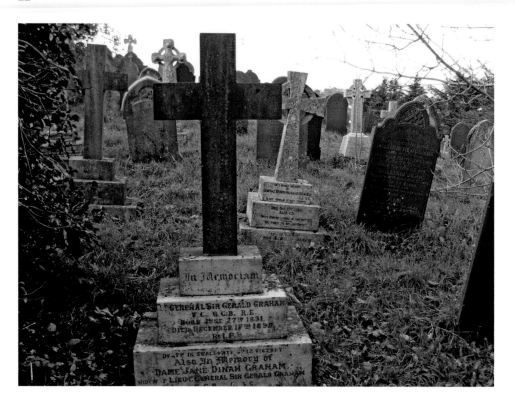

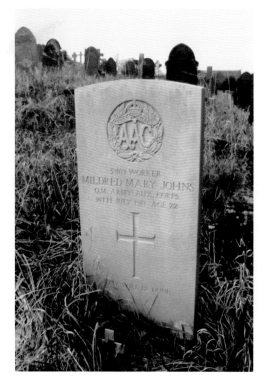

Above: East-the-Water graveyard with the graves of its two VC winners.

Left: The gravestone of Mildred Johns at East-the-Water, a First World War nurse.

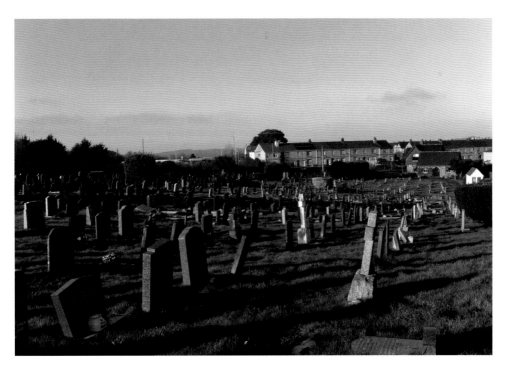

The borough cemetery at Handy Cross.

Drum Field (now the Old Town graveyard), they being guarded by men from the Somerset Militia. In 1758, *The Plymouth Magazine* carried a paragraph which read,

> Last Sunday morning (October 15) the prisoners in the French prison at Bideford (in number 1050), attempted to make their escape; but were discover'd, and fired on, by the soldiers on duty, one was killed on the spot, and several others were much wounded. They have attempted to escape twice before, but were timely discover'd.

Bideford once again housed French prisoners during the Napoleonic wars (1803–15) and when these men died they were buried locally. Over the years, human skeletons have turned up along what is now Clovelly Road. Indeed, in the early 1930s, when the houses on the right-hand side as you go up the road were being built, a whole series of skeletons were found lying head to feet. It was thought they could be the French prisoners who died during captivity and were unceremoniously buried in unhallowed ground. The skulls were apparently dropped down a well while the rest of the skeletons were loaded onto lorries and dumped elsewhere, as the workmen were worried that an archaeological dig would stop their employment at a time when jobs were scarce. Around twenty years ago, another skeleton turned up here and there will probably be more in the future.

Public and Private Monuments

One of the most obvious things in Bideford is the statue of Charles Kingsley – so why is it here? The story goes back to 1854, when Kingsley rented a house in Bideford for his family. He knew the area well, as his father had been a clergyman at nearby Clovelly from 1831. His intention in coming here was to write a novel and sell enough copies to make his finances more secure. He worked hard and managed to sell his locally set book titled *Westward Ho!* to the London publisher Macmillan's. It rapidly became a Victorian sensation, selling huge numbers in a short time and then, as with television viewers now, people wanted to see the area where the author had set his story. Luckily for Bideford, which then had very poor road connections, the railway arrived in town in 1855, thus allowing intending tourists to travel here easily.

At this date Bideford's traditional industries of shipbuilding, fishing and pottery were in serious decline and *Westward Ho!* actually sparked off a large holiday industry with many new businesses and jobs so that by 1900 Bideford was synonymous with tourism. In gratitude, E. Tattersill, who was mayor in 1904–06, launched a subscription list to raise the £530 needed for a marble statue sculpted by Joseph Whitehead. The tribute was officially unveiled in February 1906. Just a few weeks later, boys throwing stones managed to break off the quill pen the writer was holding; vandalism is nothing new. The bronze plaque and wreath were added to celebrate the centenary of Kingsley's birth in 1919.

There is actually a second representation of Kingsley in Bideford, as a bas relief over the doors of the Holiday Cottages' office on the quay where it was erected as the logo of the Bideford Building Society who constructed the building in 1937. Not as grand as the statue, but there can be few towns with two sculptures of the same novelist on display.

In addition to *Westward Ho!*, Kingsley scored another success with *The Water Babies*, published in 1863. Though a fantasy, the book helped mobilise public opinion against the terrible conditions suffered by 'climbing boys' – young children who were sent up chimneys to clean them by hand, a practice that was stopped in 1875 when the Earl of Shaftesbury piloted an Act through Parliament to outlaw it.

Oddly, a similar bill had been put forward in 1819 but had met major opposition from Sir Francis Ommaney, MP for Barnstaple, on the basis that the Act would see 'the poor

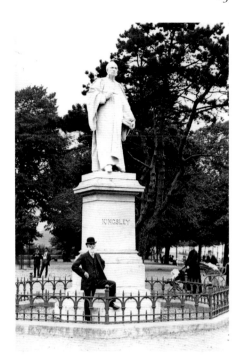

Right: The Kingsley statue in December 1913 with its original surround of dwarf railings. (Courtesy of Ann Gratz)

Below: The other representation of Kingsley – a bas relief above offices on the quay.

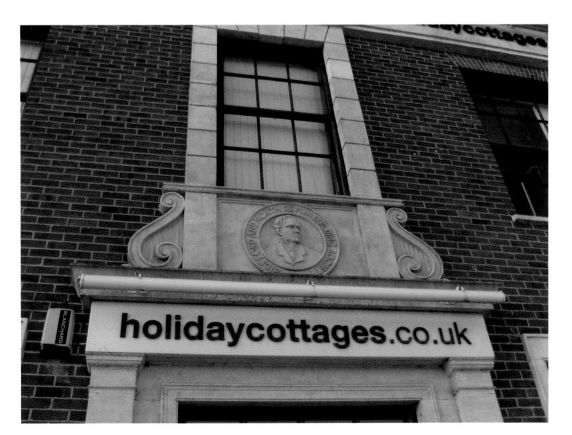

boys now employed ... deprived of subsistence'. Clearly, people connected to Bideford were rather more advanced in their outlook than those associated with its sister town!

Next to Kingsley is Victoria Park, which occupies the site of an old marsh where osiers were grown to supply local basket makers until it was filled in with domestic rubbish, with its transformation into a park which began in 1900. The plaque on the gate pillar records how George Peard presented the gates, while the railings were erected by the town council to mark the coronation of George V – they stand on what would have been the edge of the Pill when it was still an arm of the estuary.

On the corner of the quay and Kingsley Road stands the port memorial. Its history goes back to September 1881 when the customs authorities announced they were reducing the status of Bideford from a 'Port' to a 'Creek' owing to a decline in trade. This meant Bideford would be subservient to Barnstaple for customs collection and, as one might expect, this 'created much feeling among all the intelligent people of the borough'. Mayor T. Wickham went up to London to meet the lords of the Treasury to argue the case against this perceived slight, but he couldn't change any minds and 'Port' status was officially removed in 1882. This rankled and for many years the council tried to get the decision reversed, being helped by Sir William Reardon Smith, an Appledore-born ship owner who had first gone to sea in 1868 when he sailed out of Bideford. He prospered and registered every new ship he acquired at Bideford, so that by 1928 around thirty-three vessels representing 271,000 tons deadweight were registered here. This was the largest tonnage for any port in Devon.

In 1928, Mayor W. Goaman, accompanied by Smith and the local MP Sir Basil Peto, went to London to meet with the Chancellor of the Exchequer, one Winston Churchill – who agreed to reinstate Bideford as a 'Port'. Churchill's wife, Clementine, reportedly often visited her aunt who lived in Bridgeland Street; it is possible Winston had visited her here and therefore he would have known Bideford. He commissioned a bonnet for his first child from Mrs Ellis, a Bideford lacemaker. The town celebrated its new status in style with Sir Basil Peto presenting the council with the silver model of a galleon which is still displayed on formal occasions.

The following year, Dr Precourt, the Mayor of Biddeford in Maine, USA, visited Bideford. His trip coincided with the opening of the new Pill car park and the 'Ornamental Garden' at the quay end. As a mark of respect, he was given the honour of opening them – with the 'Star Spangled Banner' played in the background by the Bideford Band. The 'Garden' became the port memorial – recently refurbished to make a handsome addition to the quayside with terracotta plaques designed by ceramicist Maggie Curtis recording aspects of local fishing and shipping history on the central plinth. Another plaque records the Bideford, Westward Ho! & Appledore Railway which used to run across the site and is fixed to the Art School wall.

Chudleigh fort dominates the town. It would be even more impressive if the trees planted on its slopes hadn't grown quite so tall. The original fort was a Civil War earthwork built by Col Chudleigh in the early 1640s to overlook and control the bridge. The present-day stone-and-concrete construction dates from the early nineteenth century when the incumbent owner thought it would improve the site. The fort and surrounding land was purchased for £500 amid some acrimony in 1921 by the town council as a

Right: Local MP Sir Basil Peto with the silver galleon he presented to the town to mark the restoration of port status.

Below: Chudleigh fort rising above East-the-Water.

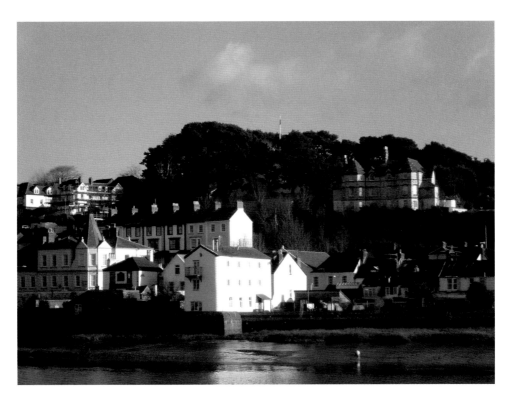

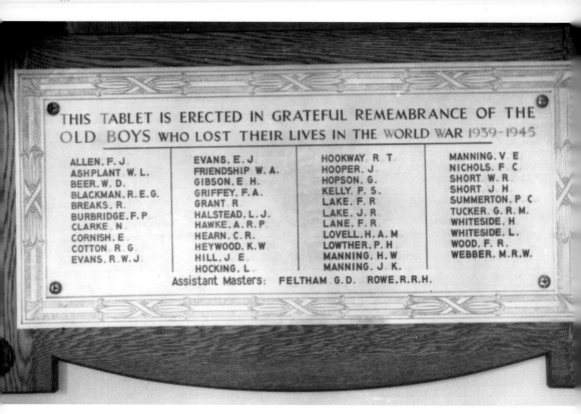

THIS TABLET IS ERECTED IN GRATEFUL REMEMBRANCE OF THE OLD BOYS WHO LOST THEIR LIVES IN THE WORLD WAR 1939-1945

ALLEN. F. J	EVANS. E. J	HOOKWAY R T	MANNING. V E
ASHPLANT W. L.	FRIENDSHIP W. A.	HOOPER. J	NICHOLS. F C
BEER. W. D.	GIBSON. E H.	HOPSON. G.	SHORT W. R
BLACKMAN. R. E. G.	GRIFFEY. F. A.	KELLY. P. S.	SHORT J H
BREAKS. R.	GRANT R	LAKE. F. R	SUMMERTON. P C
BURBRIDGE. F. P	HALSTEAD. L. J.	LAKE. J. R	TUCKER. G. R. M.
CLARKE N	HAWKE. A. R. P	LANE. F. R	WHITESIDE. H
CORNISH. E	HEARN. C. R.	LOVELL. H. A. M	WHITESIDE. L.
COTTON R G	HEYWOOD. K. W	LOWTHER. P. H	WOOD. F. R.
EVANS. R. W. J	HILL. J E	MANNING. H. W	WEBBER. M. R. W.
	HOCKING. L	MANNING. J K.	

Assistant Masters: FELTHAM G. D. ROWE. R. R. H.

Another war memorial – to the 'Old Boys' of Bideford Grammar School.

memorial to those Bidefordians who died in the First World War. The large granite war memorial cross is found here – one of the five public memorials in the town. Another consists of two large stones, one specifically for Burma Star veterans, in Victoria Park, with another, the least-known, in front of the Methodist church. Names are listed on handsome marble tablets at the back of St Mary's church, while the fifth, and oddest, is in the churchyard itself. This is a simple large Calvary Cross carved by Herbert Read of Exeter. Its oddness comes from the fact that it was erected in November 1917 – when the war still had a year to run.

It is worth noting that a second Civil War earthwork is thought to have been constructed at the end of Bull Hill where Kingsley Terrace now stands. This would have made use of the very steep slope in front of it and overlooked the River Torridge as it flowed from Torrington - a Royalist stronghold while Bideford supported Parliament. Again, the lack of archaeological excavation in Bideford means that until a dig is carried out we can say no more about this possible second defensive work.

In 1927, workmen engaged in rebuilding No. 15 High Street (now M & Co.) discovered some Jacobean oak panelling and a mantelpiece with a painted panel over, the subject being a Classical landscape, and above this a plaster panel bearing the date 1628. These fixtures indicate how grand the original house must have been. This was carefully

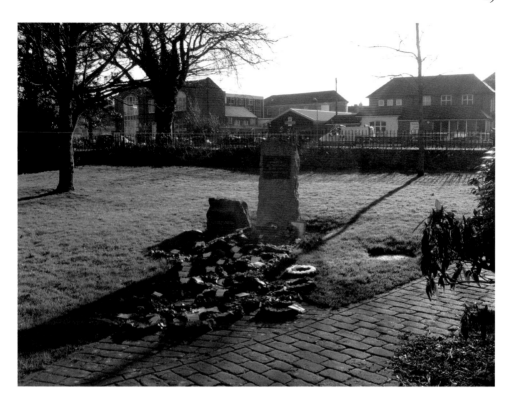

Above: The war memorials in Victoria Park pictured after Remembrance Sunday, 2014.

Right: The 1917 war memorial in St Mary's churchyard.

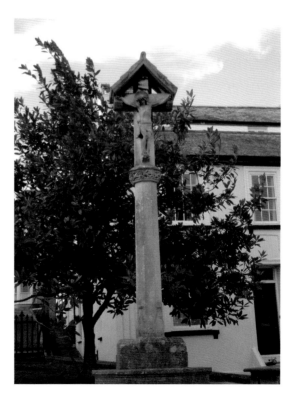

Kingsley Terrace – the possible site of an English Civil War earthwork.

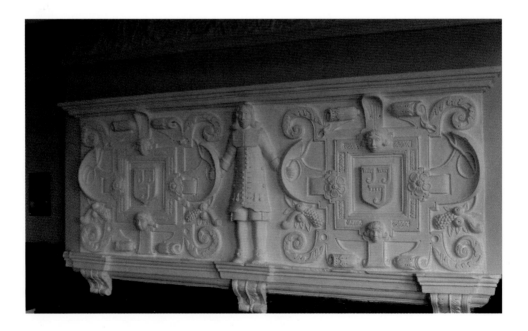

The wonderful seventeenth-century plaster mantel in No. 8 The Quay.

preserved and was on view for many years, but during rebuilding a few years ago was once again covered up.

Another such panel was found in No. 8 the Quay, though this seems to have been brought here from Stowe House, Kilkhampton, the home of the Grenville family who were lords of the Manor of Bideford for many years. David Carter, who has researched it, thinks the panel, which has the Grenville coat of arms shown on it, is by the Abbott family who were prolific local plasterers in the second half of the seventeenth and first half of the eighteenth century.

Another piece of plasterwork is to be found on the wall of an upper room in No. 1 Bridge Street. This was discovered in 1929 by two men repapering the room. Carter thinks this work displays the arms of the Meredith family of Wrexham, Denbighshire, who married into the Grenville family. This is put forward as part of the evidence pointing to Nos 1–3 Bridge Street being the Manor House of the Grenvilles, having been built around 1630 on the site of an earlier house which was possibly where Sir Richard Grenville (the hero of Tennyson's poem 'The Revenge' was born.

Bideford Above and Below

In the past, most streets in town would have been cobbled but there are few remaining such surfaces now left. Various examples can be found as, for example, Tower Street, Chapel Street, Union Street (the remnants of which form the entrance to the Bridge Street car park), the yard attached to Hart's Cellars in Queen Street and Bilton Terrace. The last of these is tucked away by the South West corner of St Mary's churchyard and consists of a few small houses that were built around 1830 on a small sliver of open land. More areas of cobbles probably still exist under modern tarmac, Church Walk and Hart Street spring to mind here, and though modern surfaces are far more disabled-friendly cobbles are more aesthetically satisfying.

As with every town in Britain there are lots of stories about ancient tunnels – in Bideford's case these are generally associated with culm mining activity. At least one large tunnel, however, is real although its history is fairly prosaic. In 1993 the Kenwith dam, built to tackle a recurring flood problem around Chanters Road and Alexandra Terrace, was over-topped and had to be hurriedly raised in height. With the improved dam in place, the decision was taken to divert extra water into the Kenwith valley and subsequently a massive underground culvert carrying the Westcombe Stream was bored from the Belvoir Hill/Lime Grove corner beneath the Kingsley School site to an outflow in the valley. This is large enough to walk through, though access is blocked by strong bars. Given the massive new housing developments on this side of the town, one has to worry that the dam will eventually fail again during stormy conditions.

In Bideford, only one archaeological excavation has been carried out and its findings published, this being in New Street, with the finds now being in the Burton Art Gallery & Museum. This is a pity as there is certainly a lot yet to be discovered. In 1874, when the present-day HSBC bank on the quay was under construction, the foundation trench for the back wall hit the edge of the old quay wall which showed just how far the quay has been extended outwards over the centuries – and hints at what there is yet to be discovered.

One excavation which might prove useful is to excavate part of Jubilee Square as, in 1896, a councillor recalled hearing from an elderly inhabitant that around 1830–40 a very large, old cannon was buried on the site by labourers who couldn't move it easily. This was the grandest of the cannons collected in the town over the years that is now displayed around the old bandstand in Victoria Park.

One of the most important parts of Bideford is hidden – the sewerage and water system which underlies the town and goes back to the 1860s. In that year, a government inspector was sent to hold an 'Inquiry into the Sanitary Condition of Bideford' following

Looking up Tower Street with its cobblestones.

The entrance to Bilton Terrace with its original cobbles still in place.

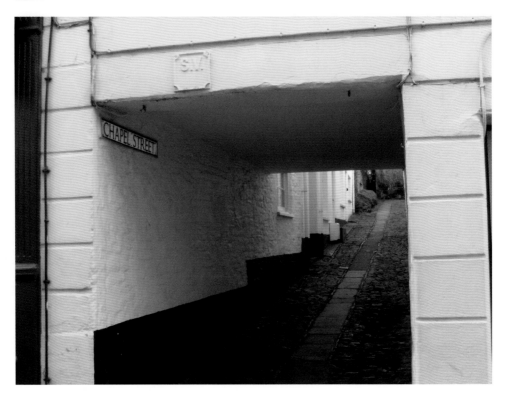

Chapel Street and its cobbles leading off of Allhalland Street.

a contentious decision by the council to borrow the huge sum of £17,000 to build a new water reservoir. The opponents of the scheme argued that it was both costly and unnecessary, as the town already had enough good water from wells.

Evidence from the townsmen makes fascinating reading with James Lee, the local registrar of births, marriages and deaths, showing that mortality in Bideford was somewhat above the national average though he didn't say why. Others were more forthcoming. Dr Thompson, a local GP, recounted outbreaks of scarlet fever, diphtheria and typhoid, all of which he blamed on 'bad sanitation' and 'overcrowding' and an 'insufficient' water supply. E. M. White, one time mayor and builder, told of a house in Bridgeland Street where the 'night soil' (human faeces) was 18 inches deep owing to a lack of water to flush it away. Even where drains did exist, they were built of 'rubble stone' rather than brick, being honeycombed by rat burrows and totally useless. Most drains discharged straight into the River Torridge or the Kenwith Stream, which flowed down what is today's Pill. A local solicitor, Mr Rooker, lived nearby and he reckoned, 'The exhalation from the large surface of mud in the Pill, and along … the quay was most offensive.' Indeed, he 'recollected one night during the very hot weather when he was sleeping with his window open, he could scarcely suffer the smell that arose from the foul matter.' T. B. Chanter spoke of a house in Queen Street, 'where the corner of the only room the family have to sit in is the only place of convenience.' (i.e. the toilet).

An early nineteenth-century print showing the public water pump in High Street, one of several that used to be found around the town.

In the face of such damning evidence, those opposing the scheme claimed that the wells in Bideford supplied all the water required and any problems that existed were due to stingy landlords who refused to pay for improvements. A Mr Dingle contradicted this, explaining how he had sunk a well in Old Town three years before and when his servant went to get water the locals came 'in crowds' to beg water from him – indeed, they 'quarrel which shall have the water first.' The leading light of the opposition was a Mr Pollard, who reckoned Bideford had no problem either with water supply or sewage disposal and after going on at some length ended on a high note. 'To pull up all our streets and construct new drains will be the climax of madness ... there is nothing, in my opinion, to justify the town in carrying out such a precarious and unsatisfactory plan.'

Following all this conflicting evidence, the inspector went away to write his report and make his recommendations. Suffice to say the wheels of local government then, as

well as now, moved very slowly and it wasn't until 1871 that Bideford finally built a new reservoir at Gammaton. Presumably, the townspeople just soldiered on and overcame their problems as best they could in the interval!

Dotted around the town are six metal columns topped by a crown and an arrow, all that remain from a large number that were erected by the council around 1902 to serve as sewer vents. They were probably purchased from the Glasgow firm of Walter Macfarlane & Co., and it is thought the crowns were added as a mark of respect to the newly crowned Edward VII while the arrows indicate the direction of flow in the sewerage pipes beneath them. Councillors were proud of them and when only a few months after they were put up, two boys were caught stoning the one at the top of High Street and were taken to court and fined 5s each. The columns were due to be removed in 1993, but I had the six best 'listed' as ancient monuments and these are now under the care of the town council – a rather quirky addition to their inventory.

For many years, Bidefordians relied on wells for water, but as the town expanded greater supplies were required. In 1920, the council decided to 'proceed with all speed' on the Jennett Stream Scheme to create a new reservoir for the town just off of the Torrington road. Three years later, at a cost of £40,000, the reservoir was opened; it still exists and the dam wall remains impressive though it no longer supplies water to the town. It is shown here just after its completion before any surrounding vegetation has grown. Sadly, and even though it was paid for by the residents of Bideford, it is now run as a fee-paying fishing lake and is not available to the general public since the privatisation of our Water Boards.

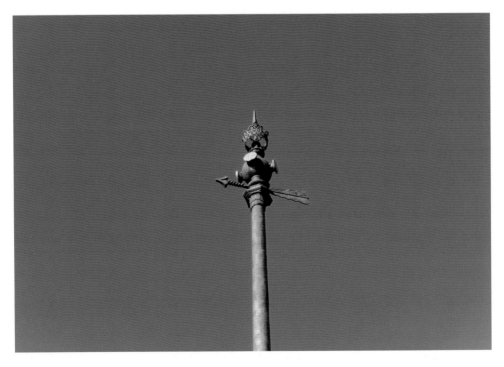

The top of one of the ornamental sewer vents found scattered around the town.

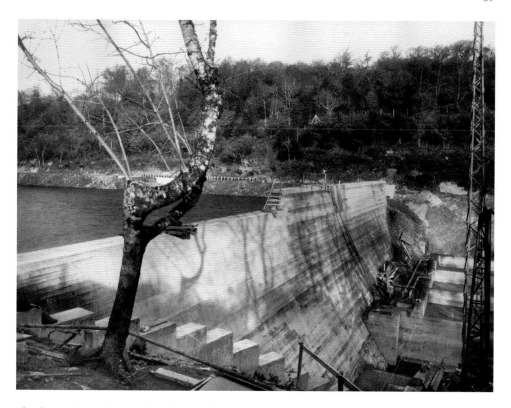

The dam at Jennet's reservoir after completion in 1923.

Bideford Library sits in some splendour at the end of the bridge, but until it arrived here in 1906 it had a fairly nomadic existence. There had been a few private libraries and newspaper reading rooms in the town before the council began considering a proper public one. In March 1877, a public meeting was held to discuss whether the town should adopt the Public Libraries Act which would allow councillors to use some of the rate money to fund a 'Free Library'.

Two groups were present; those 'known amongst us to move with the times, in accordance with the spirit of the age', and another 'who were evidently opposed to the contemplated measure.' Support was led by a Mr Narraway, who reckoned a library 'would be a place of resort for apprentices and young men, after leaving their shops and their counting houses and would not only prevent them to a certain extent from getting into evil company, but would be a resort for relaxation and recreation which would benefit them morally, intellectually and physically.' The opposition were worried the rates would rise and pointed out that hardly any of the working class had bothered attending the meeting this being taken as a sign that there was little interest in such a new facility, with one remarking that more undoubtedly would have come if they had provided 'an old fiddle and a barrel of beer.'

Ignoring this opposition, a provisional library committee was formed and set about raising funds though there was some concern that the library building itself would have

to be split into areas for the 'rich' and the poor' as the two groups would not mix. The Bridge Trust was approached and they gave £25, although at the same meeting they also voted £25 for a new church clock one of the trustees reckoning the clock 'of far more importance to them than a public library.'

With this and other funding in place, the first library was opened in Bridgeland Street in what is now the Freemason's Lodge. All went well for a year, when the building was put up for sale at a price of £400. Mr Narraway pressed his fellow councillors to buy it and thus provide a permanent home, but they demurred and it was sold. Luckily, the new owners allowed it to stay until a new home was found in 1882 in the newly built Bridge Buildings. Here it stayed until 1906, when, partly as a result of a generous grant from Andrew Carnegie, it moved into its present home. Two years later, a museum was added, though this has now migrated to the Burton Art Gallery & Museum yet the library is still in place. There are moves today to possibly re-site the collection in a new, purpose-built building next to the Burton; if this idea does come to fruition it will be just another move for the Bideford Library.

Both the library and the town hall contain small pictures in their main windows of councillors Narraway and Cock, which were inserted with their connivance by the architect without asking permission from the rest of the councillors – though they grudgingly agreed to keep them!

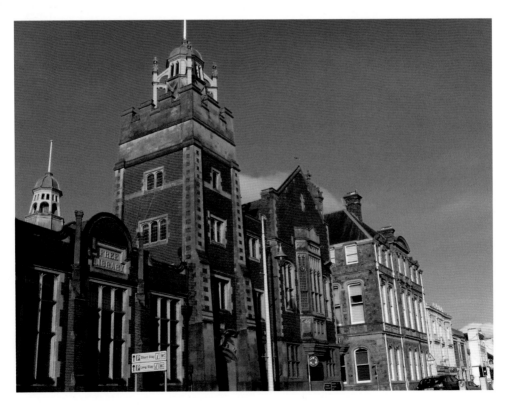

Bideford Library with Bridge Building beyond it, at the centre of Bideford.

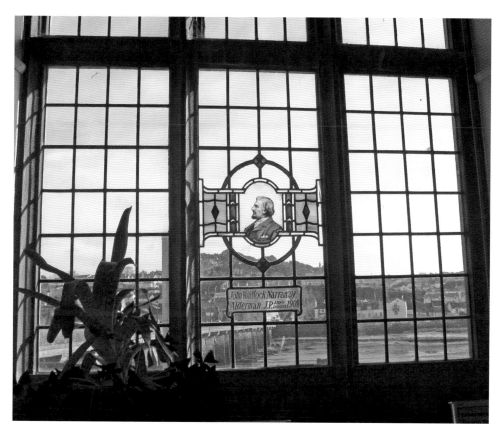

Alderman Narraway's picture in the library window.

Tower Street is a real mix of houses both in date and appearance. On the right as you look up the street are small eighteenth-century or earlier cottages, on the left are some early nineteenth-century houses with patterns worked in coloured bricks which then give way to a large Georgian house which at some time was split into two, thus destroying its symmetry. Note, however, the presence of the largest door-knocker in Bideford on this house. Go up a little further and one of the smallest houses in town is seen – with a rare example of sideways-sliding sash windows. They are, in fact, modern replicas but they do represent what most windows would have looked like in the past. At the top of Tower Street and fronting Buttgarden Street is the oddest shaped house in Bideford, it being virtually triangular! Little is known about this three-storey house but it appears on an 1842 map with a 'square' shape – so it has been added to at some time.

Allhalland Street boasts some strange features including, above the charity shop at No. 15, the only windows in the town which combine both a sash and small opening panels – with just below them in a blind window the last surviving 'fire mark'. Now painted over, this would have shown that this particular building was insured with the West of England Fire Insurance Co. – and in the event of a fire the company's fire brigade would have turned up and fought the blaze – if your building wasn't insured with them they didn't bother.

Tower Street and its varied mix of housing styles.

Above left: Sideways sliding sash windows at the top of Tower Street. Most houses would have had these once.

Above right: One corner of the 'triangular' house to be found in Buttgarden Street.

Windows within windows in Allhalland Street – and a 'fire mark' in the recess below.

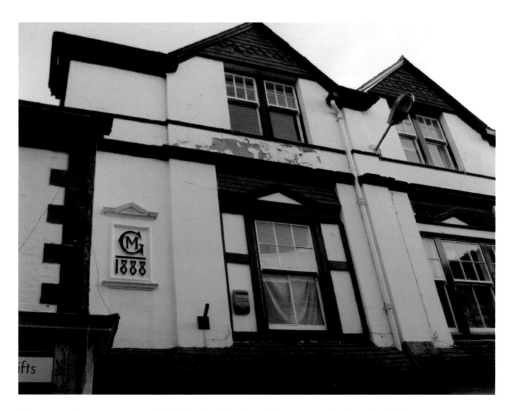

The owner's monogram on a building in Allhalland Street recording its rebuilding.

Next to this building is one bearing a monogram reading 'MG 1888', which records the date of the rebuilding of this structure by Michael Gloag, a local wine and spirit merchant. When he put up this new shop, the town council got him to give them some of the area in front as part of their long-term plan to widen this narrow thoroughfare – but as you can see today only two areas were ever given to this scheme!

One of the greatest treasures of the town is a very striking Art Nouveau painting. This does not hang in our art gallery, however, rather it is to be found tucked inside the doorway to a house in Buttgarden Street. The building, which shows many features of the Arts and Crafts movement, was once owned by T. Hamlyn, who ran a flourishing decorating business. To display his skills, he erected a gilded sign over his shop window, installed an intricate mosaic bearing his name as a doorstep and produced the painting that exists today. The building is listed, which means that the painting cannot be removed. It is now protected by a heavyweight glass panel – still giving pleasure to those who have grown up with it or who unexpectedly stumble across it.

Sometimes, even the smallest items of our street scene convey history and nothing can be more humble than the signs carrying street names. A personal favourite in Bideford is the Art Nouveau influenced plaque to be found in Lower Gunstone recording the building of Riverview Terrace in 1883. The moulded sign is not in the best of condition today but it would be a pity if it was lost.

Two sections of a road-widening scheme that never came to fruition in Allhalland Street.

The Art Nouveau painting tucked away in Buttgarden Street.

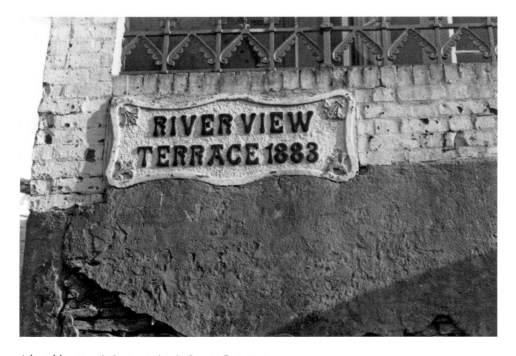

A humble yet artistic street sign in Lower Gunstone.

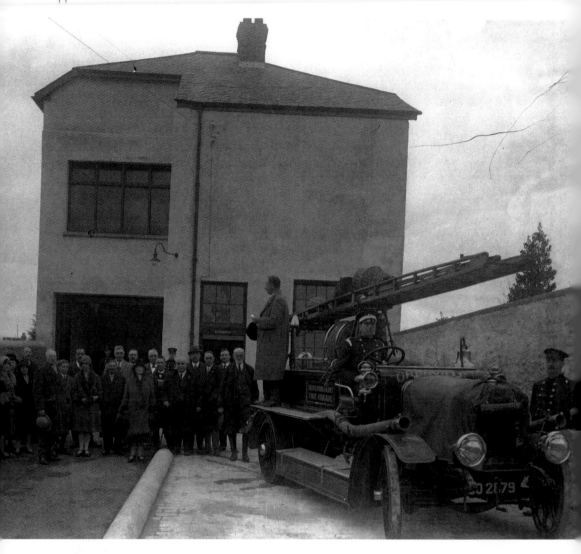

Councillors line up to be photographed with the new fire engine in December 1928; it was named 'Grenville'.

The fire station at Old Town rather oddly occupies the site of one of the most disastrous fires in the town's history. The conflagration happened in 1926 in the large school (with 440 pupils) that stood here. The flames were first noticed at 11 p.m., and within fifteen minutes the town's fire engine and its volunteer crew arrived under Capt. Morris. They were aided by a human chain formed from onlookers who began passing buckets of water forward to tackle the fire, with others removing furniture from the school. Unfortunately, a strong wind fanned the flames while the 'air was thick with smoke and sparks'. The firemen soon realised they wouldn't be able to extinguish the blaze and so turned their efforts to containing it.

The morning revealed a desolate scene with just one wing of the school surviving, while the fire had also destroyed all the school's sports cups, registers (back to 1860) and photographs of 300 'old boys' who had fought in the First World War. The pupils were rehoused in Geneva School until a new building could be provided and in December 1928 the town's new fire station was opened, literally on the ashes of the old school.

Houses in Victoria Grove are built of yellow Petersmarland brick and represent an example of wholesale development by the Bridge Trust in the mid-1930s. The trustees owned the land that later became the Old Town graveyard (set up in 1841), but by the early twentieth century realised there was a large and unmet demand for good quality housing and so constructed these houses, the architects being the local firm of Oliver & Webber. All of the houses (along with a similar development in Marland Terrace) were later purchased by the tenants under the 1967 Leasehold Reform Act and so this interesting example of houses built by a local charity has passed out of their control – though the trust do still own a small row of three cottages nearly opposite Victoria Grove which are still known by the eighteenth-century name of Prout's Tenement.

Bideford escaped the worst of the so-called 'slum clearances' of the 1960s, but a few areas were cleared the largest of which saw Providence Row and Pimlico Place disappear. These were two areas of small cottages linking High and Honestone Streets. Their small size can be gauged from a sale advertisement from 1896 which reads 'On Thursday Mr A.W.Cock sold sixteen freehold cottages known as Pimlico, High Street, Bideford. The rentals were 2s 6d per week, making a total of £104 per annum, and the price realised was £1,067.' Sixteen cottages for just over £1,000 seems ridiculous today, and even then it was cheap, though the houses in these two rows were home to 150 people, as shown in the 1901 Census. The cottages were later declared unfit for human habitation and cleared to make way for the present-day car park – leaving whitewashed oblongs on the back wall from outside toilets as a ghostly memorial, which themselves have now faded away.

Victoria Terrace is an imposing row of three-storey town houses overlooking the Pannier Market. Built into the side of the hillside, they have a fairly narrow walkway in front of them fronted with some very ornate railings. The name of the houses came from them being completed in 1837 – the year that Princess Victoria came to the throne. The railings are some of the very few early examples to survive the Second World War collection of ironwork carried out to help sustain the war effort. One only has to look at the sheer drop at the edge of the terrace to see why they were not removed – clearly safety trumped the necessities of war.

Just in front of the terrace is a red telephone box numbered 472001. The last three digits show this to have been the first public telephone box in the town, a fact that led me to have it designated as a 'listed' structure some years ago. The parking spaces in

front of the terrace are the remnants of an open-air livestock market. Apparently, metal rings were driven into the wall where animals being offered for sale were tethered. The whole area formed part of the market purchased by the borough council in 1881 from the Christie family of Tapeley Park, Instow.

In 1949, Nikolaus Pevsner toured Devon collecting material for his *Buildings of England* series, but for some inexplicable reason did not include the lovely Art Deco building on the corner of Grenville Street and Market Hill. In the 1980s, when Bridget Cherry updated the volume, I urged her to visit this building; she did and noted its 'Original jazzy glazing' and the oval panelled board-room upstairs. The building dates from 1934, when Burnett Orphoot and Frank Whiting, noted local architects, designed it for the Western Counties Building Society to replace Heywood & Cock's drapery shop. The building later became a local teacher's centre (some of whose users vandalised the panelling by sticking drawing pins into it) and then a printing business. Today, it has reverted to private accommodation but many of its original fittings still survive. Nearly opposite this building is a double-fronted shop, currently used as a café which has at the top of an outside pillar the only carving of a dragon in Bideford; why it is here is anyone's guess and it is odd no other columns have the design.

Lime Grove is one of the longest streets in Bideford and is lined on both sides with terraces of yellow-and-red-brick houses dating from the years 1890 to the 1920s. At the

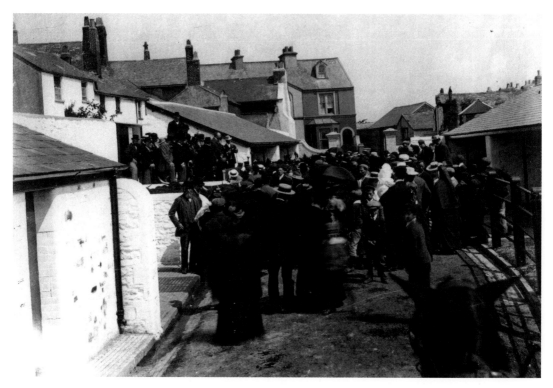

The old cattle market in Honestone Street around 1900 – with some sort of public meeting being held.

Right: The Art Deco building at the top of Grenville Street that started life as the headquarters of a building society.

Below: A dragon atop a pillar in Grenville Street.

western end are four sturdy, stone built houses that represent a piece of Bideford's history which is rapidly being forgotten. In 1896, a Miss Abbot established a school for young ladies in Lansdowne Terrace in Old Town. Under her guidance, the school grew rapidly and moved to larger premises in Belvoir Hill in 1902. These new buildings soon proved insufficient and to provide dormitories the school took over the four houses just down the hill from their main campus. During summer breaks, the school rented the bedrooms out to holidaymakers. In 1955, the school decided to move to Sidmouth and the four houses were sold to private buyers and today exhibit no outward signs that they were once the school dormitories.

Scattered around town are curious 'stone' mouldings which depict eagles and cherubs and many stories as to their origins have been told. They seem to have been purchased from the pottery at Annery, just outside of Bideford, when it closed in 1888. Baker's the builders' merchants bought all the old stock, which included these mouldings selling them to whoever wanted to aggrandize their houses though, it has to be said, some of these curious objects are rather overbearing for the small houses they adorn.

Currently, Bideford can boast only one large hotel, the Royal, although this is soon to be joined by a new one opposite Atlantic Village. In the past there were many more; one still survives, albeit as a private house. When the Belvoir estate to the west of the town was sold in the late nineteenth century, the three Groves: Myrtle, Elm and Lime, were laid out with the first house in the latter being designed as a lodging house and dining room in 1890. This might at first sight seem an odd place for such an establishment, but at this date

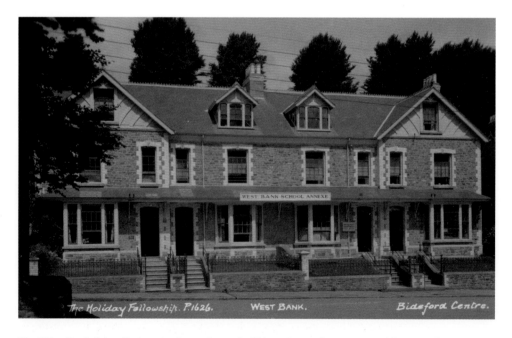

The West Bank School's dormitories at the end of Lime Grove shown on an old postcard.

Some eagles and a cherub adorning houses in Silver Street.

The old lodging house at the town end of Lime Grove.

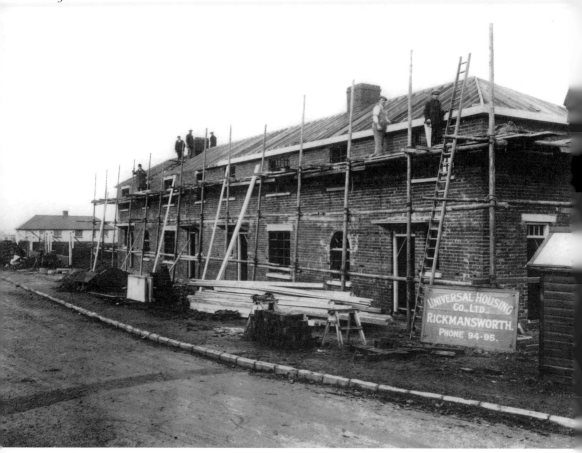

The new council houses at Sentry Corner under construction.

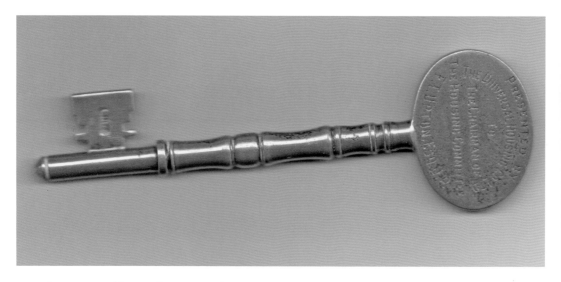

The ceremonial key used to open the first house at Sentry Corner in April 1933.

One of the ceramic 'eagles' on
top of the eponymous café at
East-the-Water, the site is now
occupied by the Royal Hotel car park.

Kingsley Road linking Bideford to Northam had yet to be built and all traffic went via the Northam Causeway, which ran between Westcombe and Raleigh Hill (today's Northam Road). Siting a hotel at the then entrance to the town made good economic sense. It is unclear when the hotel finally closed, but the opening of Kingsley Road in 1926 clearly destroyed any positional advantage it may have had – and the building reverted to private accommodation which still stands 'marooned' among a sea of ordinary houses.

Bideford's first council houses weren't built until 1924 when a few were built at Bowden Green. Nine years later, under the leadership of Cllr F. T. Upton, chair of the council's housing committee the forty-four-house Sentry Corner estate was built at East-the-Water. To mark the occasion, the Universal Housing Co. Ltd, who actually constructed the houses, presented Cllr Upton with a large ceremonial key to open the first house, which only came to light while this book was being written. The key has been given to the town council and is on display in the town hall.

Police, Prisons and the Poor

Bideford's police force as we know it today dates back to 1836, when the newly democratised borough council hired its first professional policeman – but around twenty years before this the town was visited by a Bow Street Runner from the famous London based force. In May of 1816 a local ship owner loaded a cargo of potatoes at the quay – at a time when food supplies in Bideford were running short. The poor tried to stop the ship sailing, with their attempts ending in a riot which saw the local Yeomanry cavalry (a part-time Army unit) stepping in to restore order. They arrested four of the rioters who were sent off to Exeter gaol to await trial.

The Home Secretary at this date was Lord Sidmouth, a Devon peer, and he wrote to local grandee Lord Rolle saying 'The late Proceedings at Bideford ... are of a Description so flagrant that I have thought it necessary to adopt the most prompt and decisive Measures for the Discovery of the Offenders.' This meant the dispatch of a senior Bow Street Runner, a man called Stafford, to Bideford. He was successful and arrested the assumed ringleader. In August 1816, the five prisoners were condemned to prison sentences of between two years and six months. These may seem lenient but gaols of this period were hotbeds of disease and a sentence of any length of time could be a death sentence – a terrible end to actions motivated by poverty.

Bideford's first professional policeman was based in a room in the old Guildhall (Bridge Buildings now occupy the site). This one-man force consisted of Elias Palmer, a London officer seconded to the town at a cost of £88 per annum wages. He was amazingly successful in lowering the crime rate with the Bideford Association for the Protection of Property, a private self-insurance group, presenting him with an engraved silver snuffbox to mark his work. Unfortunately, he was so successful that with fewer criminals to contend with the council voted to lower his wages in November 1844 to £38 per annum! Councillors, however, had overlooked the fact that Elias was also the rate collector for the town and within a year he disappeared with some £24 of the rates money which was never recovered, it being suggested that Elias decamped to the USA. Clearly, cost-cutting doesn't always pay dividends. The council-run police force continued until 1889 when the three-man force was amalgamated with the Devon County Constabulary.

Today's police station was constructed in 1897 on top of some very large arched cellars. Many explanations for these are current but, prosaically, they are old coal stores which were sold in 1894 along with a 'villa' called The Elms, which was demolished to make way for the new police station.

Bideford is a law abiding town, with the second lowest rate of house burglary in Britain yet it wasn't always quite so respectable, as shown by an assault case on Christmas Eve 1898. A group of men had been drinking in the Swan Inn in Mill Street (opposite Hart Street) and on leaving began singing 'indecent songs' which attracted many on-lookers.

Right: A watercolour from the 1850s with what looks like an early policeman in top hat and black frock coat standing in the road outside the town hall. (Courtesy of Burton Art Gallery & Museum)

Below: The police station with the blocked-up coal cellars underneath.

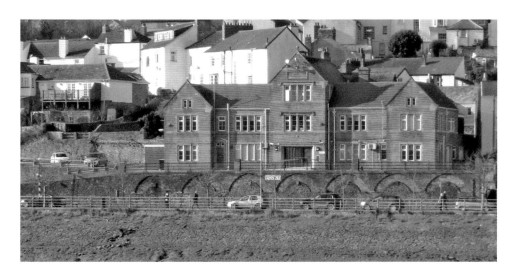

Two policemen arrived and after a warning to stop arrested the leader Ralph Whitaker a local shoemaker. He 'called upon the crowd to rescue him' and it was only after a struggle that the police could get him to the police station. At his court appearance Whitaker denied all the charges and accused the police both of being drunk themselves and of assaulting him. The magistrates chose to believe the police and fined him. Others who had tried to prevent his arrest were brought to court later and fined.

All these cases were handled by the police solicitor in Bideford, which pushed police spending in the town above budget. When the county police committee queried this, the Chief Constable, F. Coleridge, explained how his men had 'arrested some loose fellows, and were then themselves set upon, mobbed, kicked and knocked about' going on to say, 'Unfortunately in Bideford they were not always very sure that the police would get the support they received in most places in the country.' As if this wasn't bad enough, he went on: 'it was a curious fact that in Bideford there existed an industry, which paid those engaged in it, of assaulting the police' where if one was charged with assault the rest would club together to pay his fine plus a gift to the perpetrator. Clearly, the townspeople are more law-abiding today, but what an interesting sidelight this case throws on to the morals of Victorian Bideford.

Elections in Bideford have generally been fairly sedate affairs; we were never so blatantly corrupt as nineteenth-century Barnstaple (nationally notorious for the openness of its electorate to bribery), but we did have two unexpectedly violent events in 1839 and 1911. In the first, a Parliamentary election saw two local landowners, Buck and Buller, standing and emotions ran high with fights between their supporters common. On the evening before the election, John Vanstone and his wife went for a drink in the Joiner's Arms behind the Pannier Market – a stronghold of Buller's supporters. Unfortunately, the nearby Farmer's Exchange pub was a centre for Buck's men.

At 10 p.m., the Vanstones left the pub, but in the still-existing adjacent alleyway 'he joined an affray' and received a blow to his head which left him bleeding heavily. Taken home and treated by a local doctor, he returned to work after a fortnight but a fever developed and he was trepanned – where a hole was bored into his skull (without anaesthetic) to relieve pressure from an abscess on his brain. Unsurprisingly he died within a few hours, and at a subsequent inquest the coroner's jury returned a verdict of 'manslaughter against some person unknown.'

The other incident occurred in May 1911 when a Parliamentary by-election was being held with only two candidates – a Liberal and a Conservative. Baring, the Liberal, stirred up strong emotions by coming to town and denouncing 'Tory lies' and suggesting his opponents were 'pub-crawlers'. As was traditional, final campaign meetings were held in the Pannier Market and here feelings were whipped up to a pitch and as supporters poured out of the market hall, the police seem to have panicked and 'a disgraceful and fortunately rare display of violence on the part of the Devon constabulary was witnessed.' Through the crowded streets, a party of mounted police 'galloped by on and off the pavement, followed by a number of constables on foot.' As they moved through the town, 'Men and women were roughly knocked down and nervous people who had taken shelter in doorways were roughly pulled out', and even newspaper reporters 'were thrown about from constable to constable.'

The next day, complaints flooded into the mayor who passed them on to the county police committee. The chief constable expressed regret that 'well-behaved people' had been caught up 'with the rowdy element', although how genuine his regret was is open to question when one reads his final comment: 'They had only themselves to blame.' With that, the 'Bideford police charge' passed into history. Certainly, politics were much rougher in the past than they are today.

The Royal is now the premier hotel in Bideford, and is nationally famous for its wonderfully decorated plaster ceiling in the Kingsley Room, but how many know it also contains the old town prison? Down a narrow corridor are three original cells, each with a strong door with a sliding peep-hole for the gaoler to check on his charges. Today they are used as pantries – and if you want to check whether your ancestor ever spent time inside, a register of prisoners from 1838 to 1852 survives and is now in the Devon Record Office.

One of the secret aspects of Bideford's history is the existence of prostitution in the town in the nineteenth century. Research in local court records show that there were at least 40–50 women following this trade including, for example, Jane Steer who, in 1858, was charged with being drunk and disorderly. The court account noted,

The defendant is one of those unfortunate creatures who horde together in a house in Back Lane [Lower Gunstone] – probably exercising some sort of evil influence over them, as she had suspended from her neck a whistle, mysterious signals from which had often struck upon the other's ear. She is the wife of a seaman, and mother of three children, but her husband has long since given her up, owing to her bad courses.

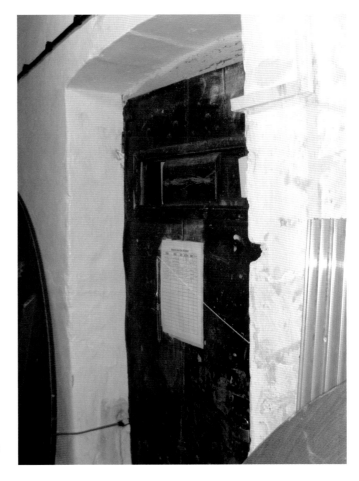

An original cell door in the Royal Hotel.

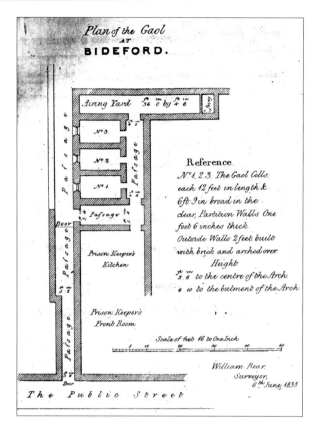

A contemporary plan of the three cells and airing yard (for exercise) which still exist at the rear of the Royal Hotel.

She was gaoled but managed to smuggle a gallon of beer into prison under her crinoline skirts!

Another notorious character was Izet Coles and a woman called Sudbury who, in 1861, were arrested by PC Vanstone for 'loitering about the Quay'. The reporter covering their case noted in a curiously contemporary comment that,

> The insufferable nuisance arising from this source form the subject of frequent complaint from the inhabitants, whose ears are offended, and their sense of propriety outraged, by the obscene language, and indecent behaviour of this wretched class of females on our Quay at nightfall.

The two were fined 5s or several days in prison. They couldn't pay so they were gaoled: 'One of the unfortunate creatures being accompanied in her captivity by her unhappy infant, scarcely twelve months old.'

Again, what are we to make of a case from 1862 when Margaret Rock who was found one night,

> In a wheelbarrow driven by William Rendall, who gave her two or three turns on the Quay, and wanted to turn her out in the street by her door ... Defendant said that Captain

Greenaway gave him 6d to wheel her home, and a pint of beer, which flew to his head. The barrow was very heavy to wheel and he put her down. Rock said she had had a halfpenny worth of beer, and a glass afterwards, and the men who were there drenched her with beer.

They were both fined.

To finish off this quick survey of Victorian nightlife in Bideford, what should we make of Eliza Bailey, 'a girl of bad character', who was charged with being drunk in 1844? She was 'found in the streets about one o'clock in the morning, lying on her back with her clothes over her head.' The magistrates discharged the woman on her promising to leave town immediately. Not quite the strait-laced prudery we associate with our ancestors perhaps!

Almshouses are the original form of housing for the poor and elderly, and Bideford had four sets: two in Meddon Street, one in Clovelly Road and one in the churchyard. The first dates from June 1646, when John Strange made his will and left five houses in Meddon Street to be used as almshouses with tenants chosen by the mayor. These were later expanded to seven houses, which were kept in repair using the rent from a large garden behind them. Famously, Strange himself died of the plague after staying in town to help the affected townspeople when others fled. In 1870, these houses were reconstructed at the expense of John Haycroft. By 1973, the Bridge Trust was then apparently responsible for them, but, finding they were too outdated to be worth refurbishing, demolished them and built the properties we see today.

In 1663, Henry Amory died willing six houses in Old Town (later a part of Clovelly Road) for 'the reception of the widows of seamen.' These were demolished in 1880 to make a road to the back of the workhouse and Inkerman Rogers, a town historian, noted, 'It is to be regretted that the old houses with quaint canopy along the whole front, lattice windows, and curious oak doors were not preserved.'

The third set consisted of four houses occupied by 'paupers of the parish, rent free' and stood in the churchyard either to the east or south of the graveyard. Around 1790, they 'fell into decay' and the Lord of the Manor, Mr Clevland, claimed the site was his. He demolished them and sold the land to James Ellis, who erected a workshop and two houses there. The fourth were of much later construction than the rest, dating from 1857, when Lewis Buck, one time local MP, paid for their construction near the top of Meddon Street. Described as being built 'in the Swiss style of architecture', they still exist, although they are no longer almshouses but, then as now, were described as 'an ornament to the town.'

Mention the workhouse to most people and it will conjure up images of stigma and hardship. Bideford still possesses its example of the 'Pauper's Prison' at the top of Meddon Street where it was built in 1837/38 to house 200, being designed to allow easy separation of males, females and children – families being split up on entering the building. Life inside was harsh with its spartan diet, uniform clothing, bare dormitories and constant work for the unfortunate inmates. For many, to enter the institution was the final stage in their life or a terrible start; in the 1851 Census for example, of 132 inmates listed twenty-six are aged over sixty (including ninety-year-old Martha Lee who claimed to be a witch) with

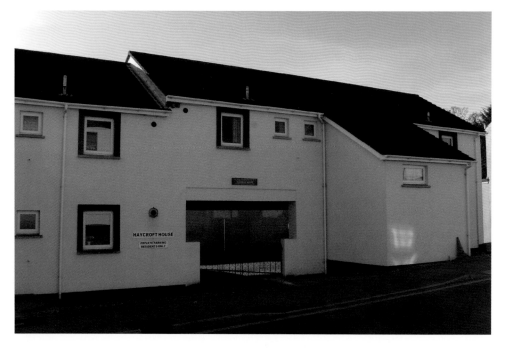

The site of Strange and Amory's almshouses in Meddon Street.

Lewis Buck's almshouses in Meddon Street.

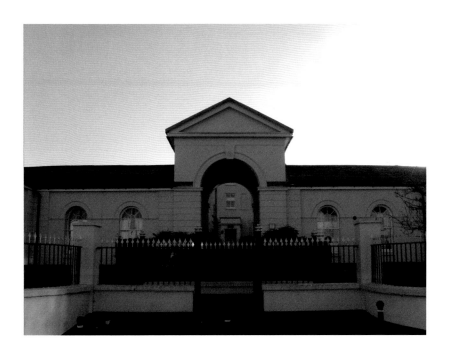

Above: The main entrance to the old workhouse in Meddon Street.

Right: The plan of the workhouse showing how families were split up.

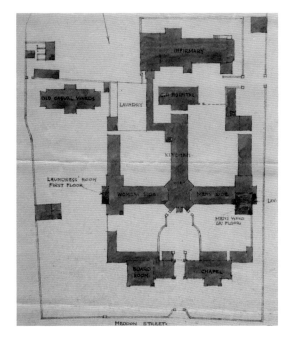

seventy children aged fifteen or under. In 1901, there were ninety-two inmates, including twenty-six under the age of fifteen.

Many will recall the fear of dying in the workhouse which our elderly relatives still had until well into the twentieth century. This stemmed from an 1832 Parliamentary Act which allowed surgeons to dissect unclaimed pauper's bodies as part of their medical training. No wonder so many of the poor belonged to 'Penny a week burial clubs' which guaranteed a proper funeral and interment – and an escape from dissection – very different from today when medical schools have almost too many bodies being gifted to them. An infirmary was added in 1903 at the rear of the premises which included a 'labour ward and lying-in ward', although being born in the workhouse often indicated an illegitimate birth. It later became a hospital and in 1948 it was taken over by the NHS, being eventually closed in the 1990s. A local housing association then took over the site and the original structure was totally refurbished as flats with new houses being built around the central building.

Getting Around

Stand near the top of High Street and you can still see ocean-going ships moored in the river at the bottom – a very rare sight in Britain today. At times, when the ships are being loaded with china clay, the quay is a hive of activity. However, when no vessels are in, one might be excused for wondering whether the port of Bideford has much evidence of its past and present use. Walk down King and Queen Street, however, and you will see at least five old warehouses where trade goods were once stored. Today, they have all been put to other uses including storage, accommodation and a betting shop – this re-use of old buildings is a common phenomenon in Bideford. Other signifiers of our maritime history are the two inscribed slate plaques let into the quay pavement outside of Mr Chips and the HSBC, which indicate where the old constricted quay used to be. Because this quay fell short of the bridge, it is thought visitors to Bideford crossing from East-the-Water would enter the town via Allhalland Street with the land in front of today's Bridge Building being small, private gardens.

Old warehouses in King Street – a link to the town's maritime history.

People buying fish and chips at Mr Chips probably don't realise the link between this building and the fishing industry. Supposedly built in 1626 as a merchant's house, the building was a large public house in the nineteenth-century known as the Newfoundland Inn – a rather odd name to find in a North Devon town, but in fact it records a very important aspect of the town's history. Newfoundland was visited in 1497 by John Cabot of Bristol, who reported that 'the sea there is full of fish that can be taken not only with nets but with fishing-basket', while around 1,600 English fishermen talked of cod shoals 'so thick by the shore that we hardly have been able to row a boat through them.'

West Country men, especially those from Bideford, became involved in this industry early on, employing a combination of 'bye boatmen' who went to Newfoundland during the fishing season and then returned home, and 'sac' ships, which collected fish caught by others. In 1699, it is recorded that twenty-eight 'sac' ships and 146 smaller boats were used by Bideford men, which was by far the largest contingent from any area of the South West. The fish was often salted onshore after landing and then sold directly to Catholic countries in Europe for eating on Fridays – with empty fishing boats being used to bring Continental goods back to England. The Newfoundland Inn was named in honour of this very profitable industry and there is still one link to the old trade when, at the annual dinner of the John Andrew charity, the trustees and their guests are served a dish of salt cod in accordance with the 1605 will of their founder.

Bideford's other half – East-the-Water – is first mentioned by a writer called Leland in the early sixteenth century, who described Barnstaple Street as 'a praty quik streate of Smithes and other occupiers for ship crafte'. The area's industrial nature goes back a long time, being based mostly on shipping. Vessels must have been built and repaired here even before Leland wrote; between 1806 and 1815, during the Napoleonic Wars, five small wooden warships were built here by William Taylor. The last shipbuilder was H. M. Restarick, at one time the mayor, who also built the Bethel chapel in Torrington Street in 1877. A strong teetotaller, he was famous for launching ships not with the traditional bottle of alcohol but with a bottle of milk! When a new housing development was built on the site of the old Barton Inn a few years ago, I had it named Restarick Close both in his honour and as a sly joke. He seems to have sold his yard adjoining the bridge around 1886 to J. Baker who consolidated the land and developed a business selling building materials – while his son, Isaac, erected the imposing terracotta plaque seen on the roadside wall. As this is being written, new developments are happening on the old wharves with new luxury flats and a marina due to rise on this brownfield site – repeating what has happened to so many old industrial areas around Britain.

Torridge Hill is, like so many other roads in central Bideford, sharply inclined. However, unlike most, it is relatively new. Until 1825, the only road to Torrington from Bideford was via East-the-Water and Weare Giffard. The previous year, plans for a new road were unveiled to run along the route used today. This was constructed by a Turnpike Trust as a toll road and all was well until it reached Bideford, where instead of going along to meet the quay it turned sharply left up a very steep, newly built road sited on top of a massive embankment. This was justified at the time as directly linking the new road to the Pannier Market. However, as a contemporary writer put it, to follow this route, 'an immense valley must be filled up, a hill lowered, and, after its completion, the ascent will be sufficient to extract a puff from a tolerably strong winded west countryman.'

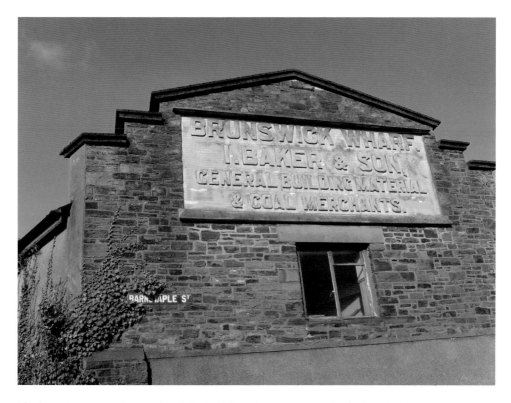

The large terracotta plaque advertising I. Baker's business opposite the Royal Hotel.

The real reason the road took this odd route was down to the owner of the New Inn at the end of Buttgarden Street, who feared losing trade if the new road went along the riverside and thus avoided his hostelry. He pulled all the strings he could to get Torridge Hill constructed – and won. Bidefordians didn't stand idly by and allow him to get away with this, as a group got together and subscribed £5 each to build the riverside road, even organising a benefit concert by a troupe of 'comedians' to raise funds. They collected enough to begin construction but ran out of money and the Turnpike Trust took over the half-completed road. They did eventually finish what became known as New Road, but charged users a toll. It isn't often one can say a new road owed its construction to corruption but in this case it appears to be true. The New Inn maintained its premier position amongst the town's hotels for many decades but in the last few years it has been converted to flats.

Bideford no longer has a railway connection but the old station still survives at East-the-Water and hosts a heritage railway group. One thing that many do not realise is that this was the town's second station. The Bideford Extension Railway to give it its correct title was given permission to construct a line between Barnstaple and Bideford in August 1853 and work went on rapidly under the contractor Thomas Brassey. Four 'over' and three 'under' bridges had to be built along with a wooden viaduct at Fremington and a tunnel at Instow – at a cost of some £44,000. The official opening took place on

One of the Bideford, Westward Ho! & Appledore Railway's engines being manoeuvred before crossing the bridge in 1917, which disappeared forever under mysterious circumstances.

The garage roof at the bottom of Torridge Hill held up by old rails from the Bideford, Westward Ho! & Appledore Railway.

29 October 1855 and the whole town was decorated with bunting and greenery while a band played for much of the day. All the ceremonies, however, were centred on the station at Cross Park – roughly where the entrance to the East-the-Water cemetery now is. The house standing here is said to have been the stationmaster's residence – and it stayed this way for seventeen years, meaning that passengers to Bideford had a long and inconvenient walk after alighting there.

The reason for this was the local MP, Lewis Buck, who owned the land between the original station and the one we know today, took years to agree to sell whilst carving through the cliff below Vinegar Hill added more time. Perhaps even odder is that the line never got a station any closer than the eastern end of Bideford Bridge – though three railway companies approached the Bridge Trust in 1846 asking (unsuccessfully) for support and, in one case, permission to lay a line across the bridge.

Just along from the bridge is the Ethelwynne Brown Close housing development. Named after an ex-mayor, the houses stand on the old railway goods yard which itself was built on land reclaimed from the river when the railway arrived. The last freight train ran in September 1982, leaving this once busy area quiet.

Thousands of motorists pass by the old stone building nearly opposite Morrison's that for many years was used to house Heard's coaches. How many realise, however, that it is one of the very few remaining features connected to the Bideford, Westward Ho! & Appledore Railway? The story goes back to 1866, when a bill was presented to Parliament to allow construction of the line, but in the event nothing was built. Indeed, it wasn't until the end of 1897 that, finally, construction actually began – only to run into serious trouble; the town council members took exception to the proposed line going right along the quay to the end of the bridge. As a compromise the line stopped nearly opposite Jubilee Square with the first passenger carrying train running in April 1901 between Bideford and Westward Ho! – the Appledore link having to wait until 1908. The line was never profitable and in July 1917 its three engines were taken across the bridge on a temporary track – the only railway to ever cross the bridge – to be sent to France to help the war effort. Their final fate is still clouded with rumour and hearsay and after the war there was no real effort to restart operations with its equipment and lines being auctioned off in August 1918.

During its working life two carriage sheds were built alongside of the track (the Kingsley Road was only laid out in 1925-6) including the one that still survives. The other was just along the road and was used by a local dairy until it was removed about a decade ago to make way for a second-hand car dealership. The only other relict of this railway are some of its rails used to support a garage roof in Brunswick House at the bottom of Torridge Hill.

Trade and Industry

The Pannier Market sits at the top of Bridge Street being owned by the district council but run by the town council. Up until the late seventeenth century, it was held at the bottom of High Street; note how much wider the street is here than further up the hill. It then moved to its present site, but we wouldn't recognise it as it consisted of a lot of open standings where farmer's wives came with pannier baskets full of produce. In bad weather, the traders were drenched but the lords of the manor, who owned the market rights, did nothing to ameliorate the problem. In 1881, as noted earlier, the town council purchased the market. They didn't immediately address the on-going problem. This had to wait until 1883 when they decided to completely replace the old market or Shambles as it was called.

While rebuilding was going on, the traders had to be temporarily rehoused. A variety of sites were suggested including behind the Ring of Bells pub in nearby Honestone Street, but some councillors said they wouldn't dream of letting their wives or daughters go anywhere near this place – which suggests an interesting reputation! Eventually, they moved to the junction of Meddon and Buttgarden Streets in 'the space below the Torridge Inn' (now converted into a block of flats still called 'The Torridge'). Here they stayed until the new market building was opened in April 1884 at a cost of £2,956 6s, an event recorded on a slate plaque over the main entrance. Intriguingly, the new market hall contained a fountain at the top of the steps from Butcher's Row which Alderman W. L. Vellacott, a local draper, had paid for, but this was soon removed, which seems a great pity.

When Torridge district council was created in 1974 they took over ownership of the building which, in 1991, was leased back to the town council. To mark this signing of the lease, town councillors march up to the market every December and after a usually short and supportive speech from the mayor distribute mince pies and 'mulled wine' to stallholders and shoppers – a pleasing, modern custom.

Buttgarden Street has the usual, for Bideford, mix of houses including two which might be said to complement each other. Just past the 1960s St Mary's block of flats is a large house containing the Jollyboat Brewery. Started some years ago by Hugh Parry, it produces a range of lovely local beers, while opposite is a house called The Old Tobacco House. This seems to have been the last surviving tobacco warehouse where the leaf was brought up from the damp quayside area to be cured ready for smoking. Indeed, a kiln was still to be seen at the rear of this property thirty-five years ago. Tobacco formed one of Bideford's links to the New World and John Watkins, in his 1792 publication *An essay towards a history of Bideford*, wrote,

> For a little more than half a century, that is, from the year 1700, till about 1755, Bideford imported more tobacco than any other port in England except London, in some years its imports of that article were superior to those of the port of London itself.

Bideford Pannier Market from the south.

'Signing the Market Lease' ceremony at Christmas 2014 with the council in the market hall.

This is a striking claim and has been reproduced many times, but it was effectively disproved by Professor W. G. Hoskins, the doyen of English local historians (and a Devon man), who wrote this in December 1935 for the *Bideford Gazette*.

At the end of the seventeenth century Exeter and Plymouth usually alternated for first place in the South-West, though Bideford was sometimes second. For instance, in 1693 Plymouth paid £3,200 in tobacco and sugar duties, and Bideford came next with £1,400. But an account of the tobacco trade preserved among the papers of the Treasury in London shows that by 1720 Bideford had out-distanced all other tobacco ports in Devon and Cornwall. In ten years (1722-31) nearly eight and a half million pounds of tobacco were landed at Bideford Quay, of which just under seven million pounds were re-exported, chiefly to the mills and warehouses of Amsterdam. Barnstaple imported and re-exported just about five million pounds each way, but no other western port came near these figures. Altogether, thirteen and a half million pounds of tobacco came in over Appledore Bar in these years, and twelve million pounds went out again.

This sounds impressive but Hoskins went on to point out that

Great though the tobacco trade of Taw and Torridge was, however, it was far less than that of London, which imported twenty to thirty million pounds annually; while both Bristol and Liverpool exceeded Bideford also.

Striking claims require striking evidence and Bideford though clearly important wasn't quite as important as Watkins would have us believe.

The old building on the corner of Mill and High Street currently houses a mobile phone shop but in 1810 it belonged to Catherine Banbury who sold it in that year to George Staveley, a local auctioneer and ironmonger, a condition of the sale being that in addition to the sale price he would pay her £40 a year for as long as she lived. Unfortunately for George, she took to swimming at Abbotsham in a flannel dress which gave her 'a fresh lease of her life', to such an extent that she lived for another twenty years! As if this wasn't bad enough, when George was refurbishing the building two of his workmen found a huge cache of ancient silver coins and promptly disappeared to Plymouth with many of them. George, however, still had a good number and must have congratulated himself on his good fortune. Sadly, John Clevland of Tapeley Park turned up at the shop saying to the unsuspecting George, 'Sir, you have found some curious coins, I presume, I should like to see them.' George obliged but Clevland's butler, who had accompanied his master, 'swept them all into a basket he was carrying', with Clevland saying 'I am Lord of the Manor, and this treasure trove is my property. Good morning sir.'

George had just one stroke of luck when he won £1,000 in a national lottery – but to the last he seemed to be one of life's losers. In the 1830s, he closed his business down and sold off the stock to some Barnstaple dealers who, when clearing out the cellar, found a 'pavement of massive iron backs for grates being placed along edge to edge', which they then sold at a large profit.

The shop itself was sold after George's death in 1837 to John Lee, another auctioneer, who was also the postmaster for Bideford and he ran the town's first post office from

George Staveley's old shop on the corner of High and Mill Streets – the site of treasure?

this building when the Penny Post was introduced in 1840. He died in 1860 and the shop then became many things, while recently it has been a tailors, showing, as with so many buildings in Bideford, the varied history they embody.

A fairly undistinguished looking shop in Grenville Street has played a major part in recording the history of the town for around 125 years. In the 1830s, John Hayman set up as a printer and bookseller in this building, selling a wide variety of books and pamphlets along with tea and patent medicines – a not unusual mix at this date. In 1852, he passed his business over to Messrs Johnson and Cole, before selling it to Thomas Honey in November 1853 and going off to Barnstaple to run the *North Devon Journal* newspaper.

After three years, Thomas decided to broaden his business interests by starting a local newspaper. The first number was published on January 1 1856 under the grandiose title *The Devon and East Cornwall Gazette and Commercial Advertiser*. In this issue, he wrote,

On making our first appearance before the public, in this form, and on the very day when we pass from the old year to the new, we cannot but feel the responsibility that must attach itself to us; and in the arduous time that lies before us, we shall endeavour honestly to discharge our duties.

Striking a business note, he added, 'To Correspondents – The Editor is not responsible for the Contents of Correspondent's letters'.

Thomas, however, knew where his economic interests lay, for he also wrote,

Advertisers are respectfully reminded of the advantages of this Paper as an advertising medium. It is circulated widely in North Devon and East Cornwall. The terms for advertising are very low, and will receive prompt and careful attention on being sent to T.Honey, Printer &c, Bideford.

The first number actually only carried ten advertisements but business soon picked up and a few even boasted an engraving to attract the eye. Thus Pridham & Lake, coach proprietors, headed their advertisements with a stirring picture of a coach and four galloping horses. The Bideford–Exeter railway service used a charming if slightly odd looking drawing of a very early train with a freight truck piled high with boxes and bags, while a fairly nondescript ship headed the advertisement for an emigrants' ship to America. These first gazettes consisted of a large double-sheet folded in two to make four pages. Three of these were probably printed in Exeter with only the front page carrying local material, with Thomas appearing to rely on friends to send him news.

The business flourished and we can imagine how proud Thomas and his wife, Eliza, must have been to insert the birth notice of their daughter, Mary, in the issue of 19 June. Sadly, however, at some time in 1856, Thomas fell ill and in the issue for 25 November appeared the following death notice: '21st inst, at Market Hill, Bideford, after a long and painful illness which he bore with Christian resignation, Mr Thomas Honey, printer, and publisher of this Gazette, aged 27.' He was buried in the Bideford Old Town cemetery and a small inscribed stone marks his last resting place.

Poor Eliza was aged just twenty-five and had a five-month-old baby, and doubtless most people thought the *Gazette* would either have to close or be sold. Eliza, however, was made of stern stuff and amazingly decided to carry on the young publication – announcing this in the edition of 16 December. A week later the *Gazette* carried a small advertisement, 'Wanted, a respectable FEMALE SERVANT, one who can undertake the charge of a Baby – Apply at the Office of this Paper. A Wesleyan preferred.' Clearly, Eliza was a Methodist who had decided that her late husband's newspaper should come before her child. Knowing how fiercely patriarchal Victorian society was, we can only marvel at Eliza's courage at becoming apparently the only female newspaper editor in nineteenth-century England. In September 1875, after nineteen years of hard work, Eliza retired and handed over the business to her relative William Honey, who did not have her staying power as in June 1882 he was asking subscribers to support the new owner, W. Crosbie Coles. Shortly after this, Coles went into partnership with a Mr Lee, an arrangement that lasted for many years even after Coles' retirement in 1894.

In the twentieth century, the newspaper passed through a few more owners before the momentous decision was taken in the 1980s to move its operations to Barnstaple where it was renamed *The North Devon Gazette*, being published as a free sheet. I persuaded the then editor to donate the old files of the paper to the town council and these now form the core of the collections of the Bideford & District Community Archive – a suitable resting place for such a treasure trove of local history.

One of the odder things to have existed in Grenville Street was an underground bottling plant in an old mine. When the street was being widened in the early years of the nineteenth century, the builders hit a seam of culm or rotted anthracite which could be used as a fuel and paint pigment. The seam on the eastern side was dug out and the large cavity left was turned into two basements one on top of the other, these being utilised to store wines and beers by Wickham's who had the large shop on the corner of the street. In the 1950s, the space was also utilised as a fully fledged bottling plant turning out beers from national breweries plus some spirits. The basements still exist today and are used for storage.

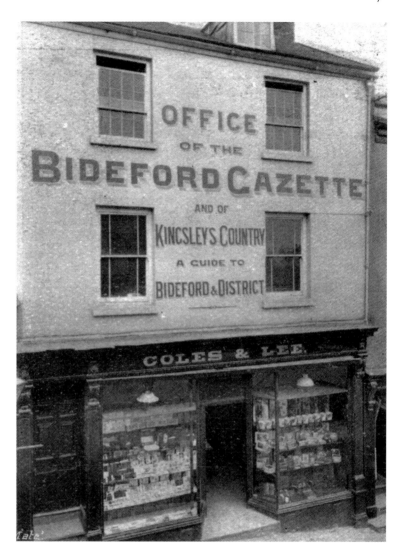

The *Bideford Gazette* offices in Grenville Street around 1900.

Industries come and go; what was once a flourishing manufacturing plant is now today's industrial archaeology. If you asked most local people what was Bideford's main industry in the late nineteenth and early twentieth centuries, you might get a variety of responses – but collar and shirt making probably wouldn't be suggested by many. Yet the 1901 census reveals that 572 men and women (mainly the latter) were employed making the then fashionable stiff collars along with the shirts to go with them – at a time when the total population of the town was 8,754.

The industry began around 1870 when a Mr Vincent established a large collar factory in the town. Within three years, they had a workforce numbering 190 with a rival setting up another factory in a barn in Old Town. Vincent then bought the old Westcombe Steam Mills, which he converted into a collar and shirt factory. Yet another factory was set up in New Street around 1874 by Messrs McBride and Orr.

The underground bottling plant that once existed in Grenville Street. (Courtesy of Basil Pidgeon)

In the late 1870s, Vincent took on A. G. Duncan as his partner and they became the largest firm in town – with Vincent becoming mayor in 1882, 1883 and 1887 and Duncan following him into office in 1885 and 1886. The New Street factory then moved to large, new premises off of Northam Road in 1883, where an existing house became the manager's residence. Another factory was also opened on Torridge Hill – which became an army drill hall in 1893. In 1897, F. Cooper & Co., another firm of collar makers, announced plans for a new factory to employ 600 hands. This was completed in 1899, and is the massive building that stands on Rope Walk. Now used by a variety of businesses and organisations, it is a strongly built structure designed to take the machinery associated with the business.

All was well until fashions began to change and by 1921 many collar workers were on half time at the factories. By the following year, the Rope Walk factory was closed with 300 being laid off overnight. The building, along with Strand House, described as 'An old world residence', was sold for £2,200 in 1923 while a separate auction saw the sale of ninety-nine sewing machines. In 1930, another factory closed with Westcombe closing in 1934. By 1937, the town's Chamber of Commerce noted, 'The loss of the collar industry had meant many hundreds of pounds per week lost in wages to operatives.' The Northam Road factory later became a glove factory but burnt down in a spectacular fire in 1940.

Walk along Mill Street and opposite the Baptist church there is a handsome building topped by a small statue known as the 'The Ragged Newsboy'. This was originally erected by Thomas Tedrake a colourful nineteenth century photographer-cum-newspaper

A selection of labels used at the bottling plant. (Courtesy of Basil Pidgeon)

publisher. He opened Bideford's first full-time photographic studio in 1862 combining this with reporting for the *North Devon Journal*. In 1872, however, he spectacularly libelled a powerful local landowner and was sacked by his editor. He then set up his own newspaper, *The Western Express*, which was noted for its outspokenness. It is uncertain when the statue of the newsboy was erected but it soon became a much loved feature outlasting its creator by many years. In 2008 a drunken lout managed to climb up some adjoining scaffolding and pushed the figure into the street where it was irretrievably

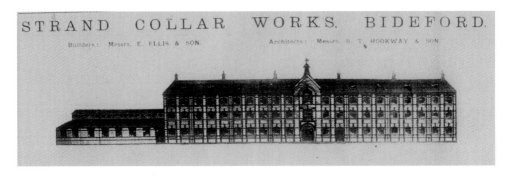

The new Rope Walk collar factory pictured in a drawing from when it opened in January 1899.

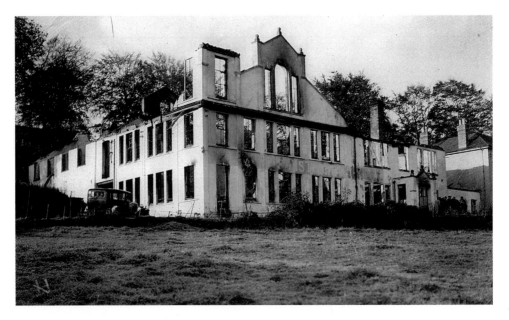

The old collar factory off of Northam Road, which became W. E. Gloves' factory and then burnt down in 1940 – shown here the day after the fire.

smashed. Local businessman Bernard Koorlander launched an appeal rapidly raising enough for a replacement which was carved out of oak by our local, but nationally renowned, sculptor John Butler. Suitably painted the new 'boy' was remounted in July 2009 and so still surveys the shoppers below.

Further along is the Bideford Café, which was once the Swan Inn and used to have a swan engraved on a glass panel above its door. This has disappeared, but one thing that probably remains is a 'sealed vessel' deposited in the foundations when the pub was rebuilt in 1911. This contained newspapers, photographs, stamps and 'a parchment bearing the names of the proprietor, his wife, son and daughter.' As far as I know, this

Above: Inside the Westcombe collar factory, pictured in a drawing from when it opened in January 1899.

Right: The original statuette of the 'Ragged Newsboy' in a 1960s shot of Mill Street.

A mermaid in Rope Walk luring you to a shop selling exquisite examples of local pottery.

Left: An advertisement listing Bideford Dairies in 1946.

MILK BOTTLE SHORTAGE

BIDEFORD DAIRIES LIMITED

GIVE NOTICE that ALL BOTTLES stamped with the following trade names are their sole property.

BIDEFORD DAIRIES LTD.	Clovelly Road, Bideford
BEER, C.	Town Farm, Monkleigh
CORK, E.	Odun Road, Appledore
EDGECOMBE, E.	Durrant Dairy, Northam
FORD, G.	Webbery Barton, Alverdiscott
FULFORD, W. G.	Glen Cot, Bideford
HARRIS, W.	Warmington Farm, Bideford
HOOKWAY, E.	Cleave Farm, Northam
JACKMAN, F. R.	Greencliff Farm, Abbotsham
MOORE, R. J.	Polkinghorne Farm, Weare Giffard
MAY, C.	The Barton, Instow
PARSONS, R. C.	Eastwood Dairy, Bideford
PRUST, F.	Marsh Farm, Bideford
PHILLIPS, J.	Winsford Farm, Abbotsham
SIMMONDS, W.	Glen Cot, Bideford
SQUIRE, J. F.	Fordlands Farm, Northam
SQUIRE, T.	The Barton, Monkleigh
WITHECOMBE, W.	Bone Hill Farm, Northam.

The co-operation of the public is requested in handing all bottles bearing these trade names to the **representatives of the Bideford Dairies Limited only**, which will be greatly appreciated.

The supports for the First World War munition factory wastepipe revealed at low tide in the Torridge. (Photograph by Steve Walsh)

Kynocks' industrial area with the gasometers still in place around 1982.

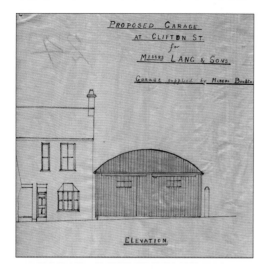

The plan for the 1930 garage in Clifton Street.
(Courtesy of Torridge District Council)

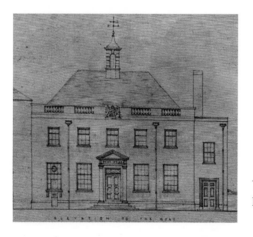

What Bideford Post Office would have looked
like if the original design had been built.

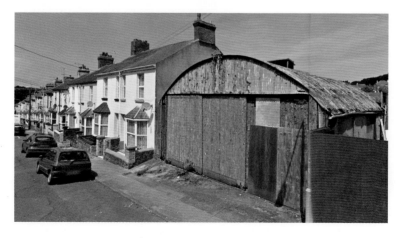

How the garage
looks today.

The plan of the dairy in Torrington Street 1932.
(Courtesy of Torridge District Council)

proto-time capsule is still there.

Walk through Bideford, or any town today, and you see countless people on their mobile phones – yet when did Bidefordians first experience the magic of the telephone? Surprisingly, one has to go back to August 1878 when a Mr Viccars of Torquay gave a lecture on this new invention in the music hall in Bridgeland Street. He illustrated it by leading a wire from some premises in Mill Street where music was played and was 'distinctly heard through the Telephones in the concert room'. This experiment wasn't followed up until 1886 when the first permanent telephone link was set up in Bideford with a telephone exchange following in 1897 located in the High Street opposite the old Chope's shop.

Continuing along the quay, look up Rope Walk (where ropes were once made) and you will see a mermaid coyly beckoning you to a shop selling examples of Bideford's famous sgraffito ware made by the Juniper family. A bit further on, one sees the bland 1960s post office, but how many know this building should have been a wonderful example of civic architecture? The plans were drawn up in the late 1930s for the structure shown here. Sadly, the war intervened and following the conflict money was short and Bideford ended up with its present-day utilitarian building.

Today, virtually everyone gets their milk in plastic bottles from the supermarket, but it was very different in the past. In 1946, an advertisement appeared in the *Bideford Gazette* appealing for the return of bottles used by local dairies in this area and as you can see there were a lot of these. Going back even further in time, the author once interviewed Wilfred Williams who was born in 1908 and could well recall that when around twelve

years old, he used to walk to a field in Abbotsham Road where the hospital now stands, and drive a herd of cows down Honestone Street to the yard of a pub called the Old Ring of Bells where their shippens were situated. Here they were milked and Wilfred would then sell the milk door-to-door, earning 6d for his trouble. Amazingly, there were two other herds of cows quartered in Honestone Street – one has to wonder what the state of the roads was like after the animals had passed?

Kynocks is a thriving area of small industrial and retail units at the bottom of East-the-Water, yet few people today know how it received its name or about the part it played in the First World War. Kynocks Ltd was a prominent firm making mostly sporting ammunition before the war, but in February 1915 they announced the setting up of a new factory in Bideford next to the timber yard of Bartlett, Bayliss & Co. producing material for the forces. This was important, as acetone and cordite used in bullets and shells was extracted from the yard's wood. Within two months, 'pre-prepared buildings' had been erected and production soon began using a largely female workforce supplemented by Belgian refugees. The factory became so important it even had its own railway siding. When the war ended, the 'Munition factory' closed and was sold in August 1919. The siding continued to be used by a variety of companies who had expanded into the timber yard – the whole being called Kynocks. Occasionally, very low levels in the Torridge reveal a line of wooden stakes which used to carry a waste pipeline from the works into the river – the only relic of this industry other than the name.

Four years before this, in 1911, the Pure Chemical Carbon Co. opened a factory here to produce charcoal and in 1835 a gasworks was set up here, with its distinctive large gasometers only removed in the 1980s. When the gasworks were set up, the owners asked the Bridge Trust for permission to run their pipes across the bridge. With permission given, gas lights were provided on the structure. This area was also the site of the Bideford Electricity Works which began in 1921 using gas from the works to turn the generators, later using waste wood and sawdust due to cheaper cost.

Some of our most common buildings have a history. Take the large garage in Clifton Street which is passed by hundreds, if not thousands, every day yet few probably ever give it a second glance. It was actually built in 1930 as one of the first garages by local builder E. Cox, as shown in the original plan. Similarly, Waves hairdresser's in Torrington Lane dates from 1932 when it was built as a dairy shop with an adjoining kitchen and bottling room with marble slabs to keep the products fresh.

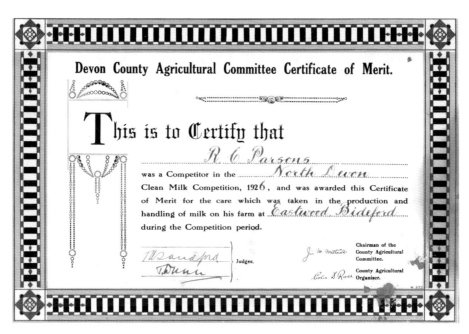

A dairy certificate from 1926 recording the care taken in the production of milk. (Courtesy of Lynn Prouse)

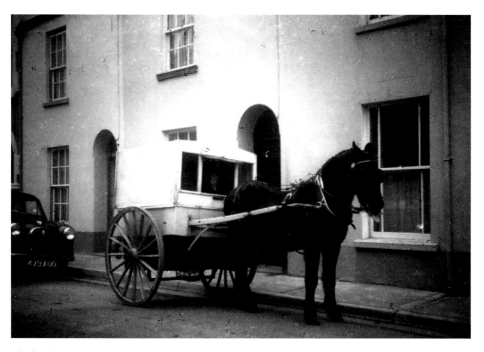

The last horse-drawn milk van in Bideford pictured in the 1960s in Milton Place; it was owned by Jimmy Crocker.

Sport, Entertainment ... and War

The history of cinema in Bideford goes back to at least 1902 when an enterprising showman presented films of the coronation of Edward VII at Bideford Fair. By 1908, these had become talking animated pictures. However, these weren't true 'talkies' but rather had sound recordings synchronised with the film. In 1910, the Bliss brothers applied to the council for a cinema licence for Pound's Rooms. This building may have been on the corner of New Street and Gunstone, as soon after the licence was granted a cinema called the Bijou was established – the building still survives today. Only a month later, the Music Hall in Bridgeland Street was also granted a licence.

In May 1918, the Heavitree Brewery constructed a new cinema at No. 16A Mill Street to hold 400. This was named the Palladium and its entrance lobby still exists as Patt's greengrocer– with its auditorium now playing host to a night club. Unfortunately, only the next year the manager of the Heavitree Arms and Cinema, Thomas Waterhouse, went bankrupt. The cinema reopened under new ownership but retained its name – while the owners of the music hall renamed their venue as the Palace Cinema. In 1936, plans for a new 800 seat cinema in the High Street were passed by the council though this never materialised – but seven months later plans for a new £20,000 cinema in Kingsley Road were accepted and the Strand Cinema was opened in July 1938.

During the war, large audiences eager to forget their troubles thronged both the Palace and Strand. However, the popularity of television began to spread in the 1950s, which saw the cinema's audiences dwindle. The Palace had actually updated its frontage in 1932, but to no avail and it closed in 1962. The Strand limped on until 1984, when it closed and was converted to the short-lived Halley's night club which also soon closed – with the building being demolished in 1991.

Today, there is still a cinema in Bideford. Run by the volunteers of the Bideford Film Society, films are regularly shown at both Bideford College and Kingsley School. Five cinemas in a small town like Bideford isn't a bad record.

Bideford today has two theatres, one in Bideford College and another in Kingsley School. They both play host to offerings by the pupils and external groups but neither see regular repertory companies, yet around eighty years ago a theatre was erected in the town to do just that. In August 1932, the *Bideford Gazette* noted,

Passers-by have been interested in the last few days to see the New Garden Theatre in course of construction on the Kingsley Road, Bideford, where Mr Will Hatton, who has made a name for himself on the stage ... is bringing his own company for this Bank Holiday week, as the special opening attraction at the New Garden Theatre.

Right: The original entrance lobby of the Palladium cinema in Mill Street, now housing a greengrocer's.

Below Right: The Bijou cinema building in Lower Gunstone.

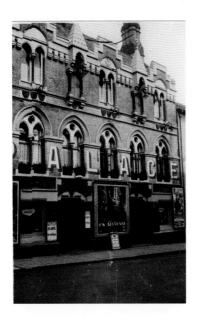

Left: The Palace cinema in Bridgeland Street pictured in 1937.

Below: An artist's impression of the soon-to-be-built Strand Cinema in December 1937. (Courtesy of Torridge District Council)

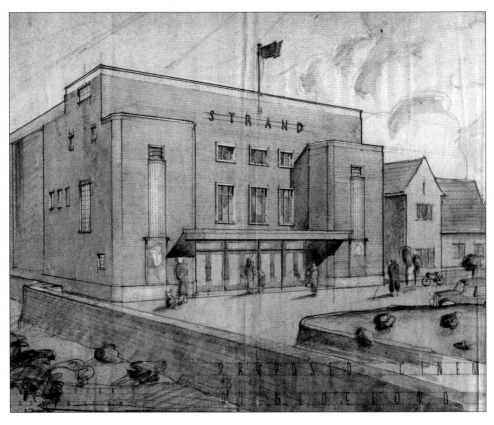

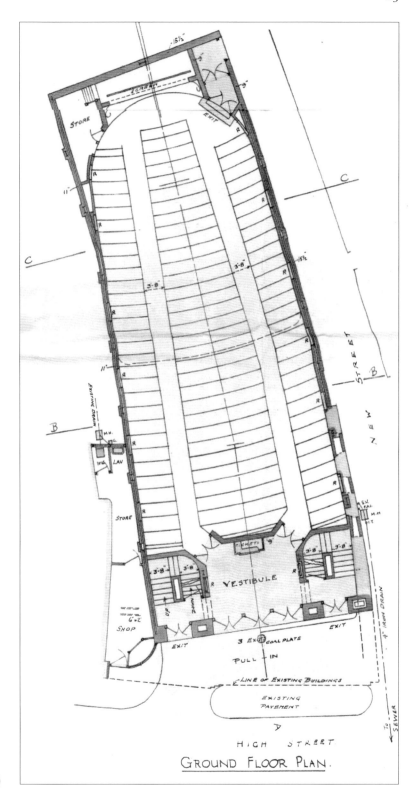

The 1936 plans for the cinema in High Street that was never built. (Courtesy of Torridge District Council)

GROUND FLOOR PLAN.

Over the next few years, a wide variety of events were staged including plays, operas, comedians and even films. By 1935, the Regent Players were in residence who 'proposed to continue presenting clean plays' which makes one wonder what had preceded them. In 1938, the then manager Sidney Foster was declared bankrupt. His replacement was Karl Dane, described as an 'Anglo-American Playboy and Film Star'. During the war, productions continued when a company who had been evacuated from London, staged shows, one actor being the then unknown teenager Paul Scofield.

Immediately after the war, however, the theatre closed and in September 1945 A. E. Hutchings, who ran a general and marine electrical and radio engineers' business, received planning permission to convert the building into a shop. The theatre then disappeared within thirteen years of opening. The building itself was only demolished and replaced with new houses, flats and shops in 2014.

Another building on the Pill has survived, this being the headquarters of the Bideford Amateur Athletics Club. Built in 1924, it was opened by Mayor Fred Upton, who reckoned that 'under the excellent discipline maintained by the popular Captain Mr W. H. Merefield the moral and physical training imparted by the Club has shaped to worthy position in life a great many sons of Bideford.' Today, he would have to include 'daughters' as well, but the fact the club is approaching its centenary is worthy of note.

Adjoining the Pill is Chingswell Street, which contains the Bideford Bowling Club. Back in 1913 when it was on the opposite side of the road, its clubhouse was destroyed by fire and 'Militant Suffragists were suspected', although no proof was ever produced. The

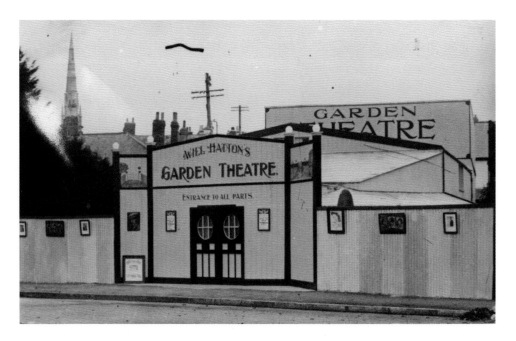

The Garden Theatre on the Pill soon after it was opened.

new green was opened in May 1922 using turf from the 'river frontage near Fremington' which was claimed to be the best in Britain.

Behind the bowling club is the sports ground. This land was bought by in 1922 for £1,475 by an individual who later sold it to a group who ran it as a business for some years before the council took it over. Today it is the home of the town's football club, but in May 1921 the first North Devon female football team played here. Their opponents were a team of local shipwrights who "were handicapped in that they were not allowed to run.' The ladies won 4–3.

In nearby Bridgeland street is the new Wetherspoon's pub, opened in an old furniture shop which itself took over Ford & Lock's Supermarket which opened in 1963. Their building in turn had replaced the Palace Cinema which had opened in 1935. The cinema took the place of the music hall and public rooms, constructed by public subscription in 1869. Its present use might have upset General Booth, founder of the Salvation Army and a famous teetotaller, who spoke in the Music Hall in August 1911 when he was aged eighty-two. Times change.

During the Second World War, Bideford only received a few bombs, but, as with every other place, Anthony Eden's wireless call for Local Defence Volunteers on 14 May 1940 saw a massive wave of recruits, with one man reputedly reaching the Bideford police station to enrol even before Eden's broadcast finished. By 1 August, around 1,046 local men had enrolled and the LDV headquarters had been established at No. 6 The Quay (recently refurbished for the Holiday Cottages Co.). Five days after this, they became the Home Guard and served as such until they stood down on 31 December 1944.

While under arms, the unit prepared the defence plan for Bideford as shown here. The road barriers consisted of concrete blocks, some of which are still to be found on the coastal footpath just past Cleave. At Raleigh, staggered stone walls slowed traffic to a crawl and ten 'oil fougasses' (improvised mines) were installed in the area which were activated by electrical currents. Additionally, two 'flame traps', which sprayed burning petrol onto the road, were built at this entrance to the town. A mortar pit near Edgehill School defended the Kenwith Valley, while Handy Cross was fortified by barbed wire and machine guns. Another machine gun post was set up on the quay along with 'dragon's teeth' tank obstacles plus anti-aircraft machine guns on the roof of the Strand Cinema. East-the-Water with its steep hills was difficult to defend and a 'moveable block of steam lorries' from the Devon Trading Co. was arranged to bar the railway bridge at the junction of Barnstaple Street and the Old Barnstaple Road. A mortar pit was sited above the cemetery and a machine gun post was set up on Pollard's Yard looking down river. Luckily, perhaps, these defences were never needed though it is known that the Nazis saw Bideford Bridge as a prime strategic target if they had invaded.

The local Home Guard also boasted a 'secret' section of around ten men who were tasked with harrying the Nazis following an invasion. One of their ammunition stores was kept under the floorboards of the old mission church on the Alverdiscot Road and they had three carefully concealed operational bases. However, these were all destroyed following the war.

No buildings are ever permanent and this was especially true during the two world wars when special buildings were hastily thrown up and just as quickly dismantled after

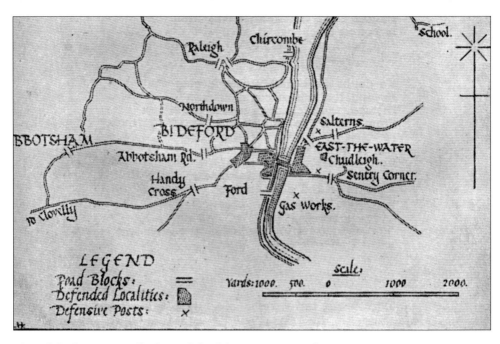

The Bideford Home Guard's plan to defend the town in time of invasion.

PUBLIC SHELTERS.

Public Shelters have been provided in the Borough, these are of the surface type and are intended primarily for the use of persons caught in the Streets during a raid.
The Shelters are situated at—

Quay Road—Wharf side.
Pill Road.
Quay Road—Jubilee Lamp site.
Market Place (Square).
Market Place (Angel Inn).
North Road—Kingsley Street.
East end of Bridge.
Mill Street—Baptist Church Garden.
Fire Station Yard.
St. Peter's Churchyard, and at
Coronation Road.

Wardens are in charge of the Shelters.
In addition to these public Shelters certain premises in the town have passages, basements, etc., suitable for use as Shelters and notices in the windows of such premises indicate that the owners are willing to allow the basements, etc,, to be used by the general public in an emergency.

The wartime list of Bideford's air-raid shelters as published by the borough council.

A post-war plan of the air-raid shelter in Mill Street in front of the Baptist church. (Courtesy of Torridge District Council)

hostilities ended. A large camp of Nissen huts at Handy Cross, for example, was erected to house displaced persons at the beginning of the Second World War being later used by the US Army. After the war, it was cleared and new industrial and retail units were built on the site but now some of these have gone to be replaced by modern houses. One class of structure that was hurriedly built around the town was the air raid shelter with eleven provided by the borough council, as shown in this list taken from their 'Air Raid Precautions' booklet. The plan of the one built in front of today's Mill Street Baptist church is shown here – clearly a very utilitarian structure. Only one has survived through to the twenty-first century, this being next to St Peter's church at East-the-Water – a rare relic.

Odds and Ends

There can be few settlements that can boast (if that is the right word) a visitation by the Devil, but Bideford is one. This 'fact' came out during the trial of the three Bideford witches: Temperance Lloyd, Susanna Edwards and Mary Trembles, who are generally accepted as the last people to be executed in England for the crime of witchcraft. After they had been arrested in 1682, Thomas Eastchurch, a 'gentleman', gave evidence on oath that,

> He did hear Temperance Lloyd to say and confess that about the thirtieth day of September last past, as she was returning from the bakehouse with a loaf of bread under her arm towards her own house, she did meet with something in the likeness of a black man [a euphemism for the Devil] in a street called Higher Gunstone Lane within this town.

There was a lot more of this 'evidence' and anyone reading it today can only presume the women were suffering from dementia. Unfortunately, 300 years or so ago this condition was not recognised and the three were found guilty of witchcraft and hanged at Exeter on 25 August 1682. Today, there are no physical links to the story although there is a long-standing tradition that one at least lived in a small cottage in Old Town which burnt down in June 1894. In 2012 I had a plaque recording the women erected on the Town Hall this being the only memorial to women in the town.

Bideford's links to witchcraft extend far beyond the seventeenth century, though later practitioners weren't executed. Belief in the powers of witches continued; a case from 1851 saw a greengrocer with a shop in Mill Street, who also kept pigs, suffer a setback when 'one of the young grunters died, and the others were taken violently ill.' The man's wife immediately 'published it abroad that the pigs had certainly been overlooked by the Cock-street witches, and would all die!' Clearly, people still dreaded being cursed – and in case you haven't come across Cock Street this was the old name for Hart Street, which the Victorians changed, clearly thinking its original name too coarse.

In July 1874, newspaper readers would have seen the heading 'Enlightened Bideford' and read that 'Bideford is no place for rogues and thieves, for within the boundaries of the ancient borough there is a mysterious power of detection far surpassing anything that Scotland Yard can ever hope to produce.' The story revolved around a couple who had lost a treasured silver watch. Paying the town crier to announce a £2 reward for its return yielded no results, so the wife suggested 'a consultation with the white witch [otherwise wizard]'. The wizard isn't named, but she visited him to be told that 'the watch could not only be recovered, but for an additional half-a-crown she could see the likeness of the woman who had it.' The gullible woman paid the extra and was told 'to stare through

IN MEMORY OF
Temperance Lloyd,
Susannah Edwards
& Mary Trembles,
all of Bideford –
hanged in 1682, the
last to be executed
in England for the
crime of witchcraft.

The memorial plaque to the three Bideford 'witches' on the town hall.

something with one eye' but what this was we are left to wonder, though she claimed to have recognised the thief.

Returning home, she carried out some further instructions from the wizard including saying 'certain incantations' while stirring a kettle over the fire and her husband had to whistle through the keyhole of their door for an hour! The next day they found the watch 'in an old pocket' under an apple tree in their garden. Presumably this was in a forgotten coat and we might laugh at the whole thing, but clearly there were still Bidefordians who believed in witchcraft in the nineteenth century.

Indeed, this belief extended into the twentieth century. In 1901, Sarah Sayers, a widow living in Silver Street, was charged with 'telling fortunes ... contrary to the Vagrancy Act of 1824' after being caught by an undercover policeman. This followed her charging a labourer £3 3s to remove an evil 'overlooking' (curse) from both him and his father. In fact, there are still stories in circulation about an elderly woman who, between the wars, used to be found daily near today's rugby club who, for a monetary consideration, would tell fortunes and even cast spells. We may smile at these things today but how many of us still read our horoscopes and throw a pinch of salt over our shoulder? Belief in odd things is very tenacious.

Oddly enough, where Temperance claimed she had met the Devil was the site around 250 years later which witnessed what was termed a 'miracle'. In 1836, the Bideford British School was built at the top of Higher Gunstone by local Nonconformists. This school saw generations of youngsters pass through its doors, but in March 1892 around eighty infant boys were being taught in the large classroom on the upper storey of the building when 'without a moment's warning the whole ceiling from end to end fell bodily upon the occupants of the room.' The children were completely buried under a 'mass of beams, joists, laths, plaster, gas pipes and pendants'.

Hearing the noise of the crash, Mr Baxter, the headmaster, ran upstairs to be greeted by a scene of complete devastation, made worse by the screams of the trapped infants. He immediately began scrabbling at the rubble and was rapidly joined by terrified parents. Amazingly, and against all expectations, the children began to be pulled out alive in ever increasing numbers until the final one was extricated. Astonishingly, not one child had even suffered a serious injury, which left the adults 'dumbfounded at the almost miraculous escape of the little ones.' The explanation was simple – the heavy ceiling had crashed down in one piece pushing the small boys under their solidly constructed iron and wood desks. Here 'though well-nigh smothered and horribly frightened, they were not crushed.' How odd that Bideford should have the Devil and a miracle in such close proximity!

There are few surviving links with Bideford's Elizabethan past – and one is a mystery. In 1894, Thomas Tedrake, proprietor of the local *Western Express* newspaper, published his *Illustrated Guide to Bideford and North Devon* in which he wrote of the Castle Inn in Allhalland Street (next to the Bridge Buildings), being part of the residence of Sir Richard Grenville – once the town's lord of the manor. There is no proof that this was his house, but Tedrake does note that a picture over the public bar showed 'the Fort of Virginia and two ships with the Grenville flag passing under its guns.' Tedrake says this was painted on Grenville's orders, but, by 1894, unsurprisingly, it was 'somewhat blurred and obscured by dirt and varnish.' Three years after Tedrake published his book, a couple visited Bideford and recorded seeing the same painting noting that they were told that 'persons had come from America purposely to see it, and they [the publican] had been offered thousands for it, but of course it could not be sold as it is painted on the wall.' Apart from these two references, the painting seems to have disappeared – but to where? The Castle ceased being a pub in 1918.

The pub was also the home of Alfred Denbow, born in 1843, who was a 'calculating prodigy' who could do prodigious feats of mental arithmetic. While young, he attracted the attention of the Society of Civil Engineers and George Bidder another, older 'mental calculator' from Moretonhampstead. They paid for Alfred's education and on leaving school he was apprenticed to an engineering firm in Stockport, while his first job after serving his time was helping to build Smithfield Market in London. He then went to the USA and was employed by the First National Bank, later being made a partner. He died in 1891 aged forty-eight, apparently still having his calculating gift.

One of the 'secret' places in Bideford is no longer as closed as it once was. The Bideford Freemasons are today based in their own Lodge in Bridgeland Street – where they have come to rest after a fairly peripatetic history. They can trace their history back to around 1775 when they were formed as an offshoot of an Appledore based group. This first lodge

Alfred Denbow, a calculating prodigy, aged eleven, as pictured in the first issue of *The Bideford Gazette & Monthly Advertiser* in March 1854.

only lasted two years and it wasn't until 1783 that a new lodge, called The Good Intention was set up by Thomas Anter from the North Devon Militia, but where it met is unknown. In April 1792, a new group called The Faithful Lodge began meeting in the Newfoundland Inn on the quay – today's Mr Chips. This lasted until 1823 and there wasn't a successor for twenty years when the Lodge of Benevolence was formed. Originally housed in the town's Commercial Reading Room in the High Street, it moved back to the Newfoundland Inn and then to the Masonic Rooms at No. 9 Grenville Street. From here they moved to a hall in Bridgeland Street before finally coming to rest in the present-day Masonic Hall in October 1875. This had been the house of Thomas Stucley in the eighteenth century, and on his death the new lessees (the building is owned by the Bridge Trust) found a groove worn in the floor by his constant tramping in front of the fireplace. The interior of the building today is spectacular and must rank as one of the most amazing in Bideford.

An 1857 report in the *North Devon Journal* begins, 'It must create a very curious and not very pleasant sensation for a man to find in the morning ... one of his limbs ... lying, when he awakes, in everlasting separation from him at his side.' The man was George Slewman, then aged eighty-nine, and living in Torrington Street. Described as being in good general health with 'intellect unimpaired' his age had seen him be 'a bed-lier for

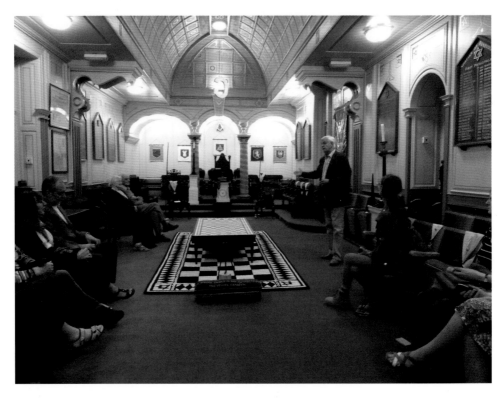

Inside the Freemason's Lodge in Bridgeland Street during a visit by a group of interested locals. (Photograph by Andy Marshall)

the last seven years.' In 1855, he began feeling a pain in his heel and his wife, thinking it was rheumatism, gave him a worsted stocking to keep his foot warm. Over three weeks, however, his lower leg and foot became swollen with liquid oozing out. Within a few days, the affected area first turned brown and then 'perfectly black', the skin being described as 'hard as horn'. The leg remained in this state for thirteen months without any further change occurring.

Then one night, while George was asleep, he awoke 'with a convulsive start' to find his leg 'had actually dropped from his body.' Dr T. Pridham, who was called in to view this amazing case reckoned that his patient's sudden awakening had 'snapped the decayed bone asunder' and caused the useless leg to drop off. There was no bleeding and the stump looked as clean as if surgery had been carried out. Apparently, George kept the leg which was 'exhibited as a curiosity to any friend who might call' – which suggests he had some fairly morbid acquaintances! George had a powerful constitution and survived. Indeed, he triumphed as, after losing his leg, he was 'now in comparatively good health.' He died within a year, which was not perhaps surprising as he was then ninety. He clearly must have been a tough character.

Another curious story comes from this street. In February 1865, a newspaper story appeared with the headline 'Extraordinary case of abstinence from food' which featured

Susan Mock, the fourteen-year-old daughter of James who was a shipwright living here. The case began the year before, when Susan was 'affected with symptoms that were believed to be rheumatic' and her 'stomach became very irritable', to the extent that she found it difficult to hold food down. As her illness developed her spine became sensitive, her neck shook constantly and her voice sounded like a succession of hiccups.

Medical advice suggested a change of scene to a fresher, breezier area and when this was done her shaking ceased and her voice returned – but now she could not eat at all. At this point she was 'injected' or force-fed milk and broth but 'at length the girl objected so strongly that the injections were omitted occasionally and at length discontinued.' At this point, her doctor announced his 'complete abandonment of the case' and said that he was certain hunger pains would compel her to eat. In August, however, the newspaper reported that 'she has now been over six months without being known to take a morsel of food or to retain any fluid in the stomach,' being in a sort of state of hibernation interrupted by hysterical fits. As one would imagine, physically she was 'greatly emaciated, her spine being particularly distinct and every bone in it defined.' The reporter assured his readers as to the truth of this story and oddly there are quite a few similar accounts in nineteenth-century medical literature. There is no entry for Susan dying for ten years after this in the registrar general's records and one can only assume she began eating again – certainly there are two entries for the marriage of a Susan Mock in Bideford in 1871 and 1876, and it would be nice to think that one of these concerned said Susan.

One of the old traditions of East-the-Water was the election of a mock mayor. These were seen as a spoof on the real mayor and were set up to puncture the pomposity of this grand person. The earliest reference is a newspaper report from November 1856, which read, 'The suburb on the other side has for years enjoyed the self-created right of choosing a Mayor to govern and decide all matters connected with the East.' In that year, George Isaac, a shoemaker, was chosen and arrayed in 'a red gown and a large tam o'shanter on his head' and was hauled across the bridge on 'a two wheeled chariot' (a wheelbarrow), stopping for a drink (or three) at the local pubs. Various others followed and in 1868 the incumbent was called the 'Mayor of Shamwickshire' for the first time, this being a slang name of unknown derivation for East-the-Water. The officeholder seems to have been one William Congdon and in October 1869 he was charged with being drunk and disorderly and fined 2s 6d. On the 1872 occasion, the 'mayoral' robes were described as being 'an old soldier's coat wound round with a Union Jack'. We are also told that he visited his friends, 'most of whom resided at hostelries' in a shipwright's cart 'drawn by a dozen stalwart fellows'. In 1876, the 'mayor' was elected on 10 November, which apparently was the custom day and his speech was reported in some detail. He defended 'small farmers', saying he would redistribute land if he could, went on to denounce the cold and draughty Pannier Market and ended by attacking the town's poor water supplies and drainage system.

Other 'elections' are reported in 1876, 1879 and 1881, but after that there were no more mentions until 1935 when a historic meeting was held between the real mayor, Cllr W. E. Ellis, and his 'Shamwickshire' counterpart, T. Squires. This was to mark the Silver Jubilee of George V and a celebration party was held in Torrington Street with the singing of 'For He's a Jolly Good Fellow'. The tradition appears to have died out during the war, though it was briefly

revived in the 1950s and in 1995 when Pat Jeffery became the first female mock mayor. The following year, Tommy Johns took over and the time is probably ripe for reviving it in the twenty-first century.

Walk down Torrington Street and near the Blacksmith's Arms is an imposing three-storey building called Torridge House. In the 1850s, this was the retirement home of Admiral Glyn who died in 1858. His obituary records an odd story about the house from the eighteenth century when Viscount Annesley, an Irish baronet, was introduced to a Bideford heiress called Ann Prust, who owned the house. He courted her, they married and, as was the law then, all her property passed to him. Sadly, for her, he proved to be a wastrel and within a year had mortgaged all her property and 'indulged for some time in a course of gaiety, and in possession of those enjoyments which a large fortune placed within his reach.' When Ann complained, he 'kept her immured in the house for some years' with a keeper to prevent her from leaving. Fortunately, a Bideford solicitor, one Mr Hillow, discovered her plight and secured her freedom and gave her sanctuary in his own house from where the Reverend James Hervey, curate at St Mary's church (later to be a famous author), 'walked daily with her to and from church that no attempt might be made upon her liberty.' What happened to her is yet to be discovered, but women today can be glad that such gross legal inequalities have been remedied.

The Nationwide Building Society office on the quay is a fairly modern structure, which replaced an older one that housed the dispensary – Bideford's first hospital. In 1879, a twenty-four-year-old servant called Mary Bray was carried here from her master's house in Mill Street, having spread arsenic on a piece of bread and butter and eaten it – not to commit suicide but rather to help clear her spots! At that date, women freely dabbed arsenic on their faces to both cleanse and whiten their skins.

Mary, it seemed, rather overdid the treatment. An inquest was held at the dispensary where twelve jurymen viewed her body (the practice back then) and adjourned to a small room to discuss the case and reach their verdict. Unfortunately, eight wanted a simple statement of death by arsenic while the rest insisted on a suicide verdict. Majority decisions were not acceptable and ten hours later, at 1 a.m. they were still deadlocked. Their room was described as 'a small ill-ventilated room without a fire' which became full of tobacco smoke. The coroner ordered them to be locked in without food, water or heat until they had reached a verdict. The next morning they were still there and the impasse was only broken when the girl's employer gave a new statement which saw the jury deciding, 'That the deceased died by an overdose of arsenic'. Therefore, they attributed the blame to no one, but the way it was arrived at added another curious page to the town's history.

One person possibly connected to Bideford is an international puzzle. In 1902, Harry 'Breaker' Morant, an Australian trooper in the Boer War, was executed after a court martial for shooting prisoners. His death created a huge outcry in Australia with ramifications for Australian forces extending into the First World War and a litany of books and articles written on the case, which still appear today. Morant claimed to have been born in Bideford at Christmas 1865, the illegitimate son of Admiral Sir George Moran, and in his surviving poems and letters he refers to Devon. It appears more likely that he was born Edwin Murrant in Somerset, but there is apparently a photograph of him taken by Puddicombe, a Bideford photographer. As to the truth of his life story, it will probably never be proved one way or the other.